199 FLAGS

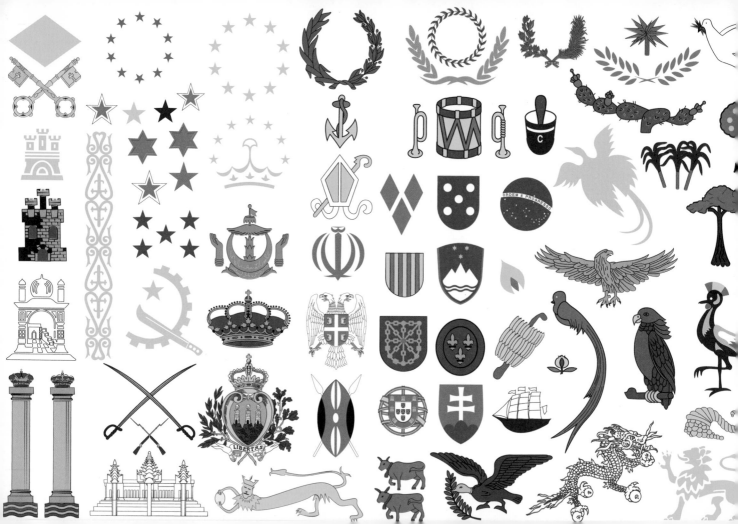

199 FLAGS

Orith Kolodny

CHRONICLE BOOKS

SAN FRANCISCO

FLAGS AND SHAPES

What is a flag?

It comes in the form of a piece of fabric whose size, shape, design and colors vary. It is usually attached to a pole or rope to allow it to float in the wind.

A flag is used to identify a group of people, an organization, a nation or a state. For a country, the flag is an important symbol of pride and independence. Nowadays, each country has its own. Some are simple, others more complex, but they all have special meanings.

Why should flags interest us?

A flag is the visual representation of an idea or concept. It embodies values, beliefs and commitments; with very few elements, it tells the story of a country or denotes a distinctive contingent. The sometimes extremely simple design of this piece of cloth has the amazing power as a symbol to rally millions of people behind it!

Why were flags invented?

Flags are the result of a history of battles, conflicts and wars, but also of ceremonies and celebrations. They affirm belonging but also possession.

People have used flags to proclaim their presence in a territory, hoisting them to the tops of fortresses or tents, or raising them on the masts of boats.

The flag often inspires a particular respect. In battle, losing the flag was a severe blow and often changed the outcome of the conflict. "Capture the Flag" is still a very popular children's game.

Why is a flag changed?

National flags — flags that are emblems of a state — first appeared in the 17th century, when the first modern states were created.

A hundred years ago, there were about 60 sovereign states with flags.

Today the United Nations has 193 member states. Flags are a mirror of the evolution of people and ideas. That's why some of them undergo more frequent changes than others: for example, the flag of Afghanistan has existed in more than 20 versions over the last 100 years.

When do we raise the flag?

A country's flag is raised or lowered to half-mast during ceremonies.

Every athlete dreams of standing on the podium while their country's flag is raised. At the Olympic games, the winners sometimes wrap the flag around their shoulders, and the fans wave flags to show their support.

One of the most celebrated events in the 20th century is the moment the American flag was planted on the moon. Mountain climbers also plant their flags when a summit is conquered for the first time. In Denmark, flags are even flown at birthday parties.

What are the elements of a flag?

Flags are composed of very basic elements. They combine simple shapes in varying proportions, and a given combination forms the flag's singular identity. Simplicity is indispensable, so the flag will be easy to recognize and reproduce. It allows the flag to be seen and identified from a great distance. Symmetrical shapes are helpful for recognizing the flag as it waves on its pole.

What is the basic structure of a flag?

It is not easy to represent the entirety of a nation on a swatch of cloth! Each culture uses different symbols and shapes that have meanings understood by all, based on various colors, elements or figures. The choice of shapes and symbols and their arrangement on the flag make it instantly recognizable.

How can flags be categorized?

Classifying flags into several categories can help us understand their structure and origin. There are those with stripes — horizontal, vertical and diagonal — and triangles, circles and crosses. Figurative shapes often represent natural objects: sun, moon and stars. Also found on flags are plants, birds and more complex elements representing decorative features, weapons or monuments. Lastly, flags occasionally feature words or mottoes.

How to read this book

After identifying the dominant shapes on each flag, the book places them in categories that are completely independent of the country's name or location. Thus the flags of Morocco, Israel, Uganda and Papua New Guinea, or those of Lebanon and Canada, are grouped together. This unusual categorization lets us connect shapes with ideas — and understanding the significance makes the flag easier to remember. A glossary at the end explains the words marked with asterisks.

COLORS

Why do flags have bright colors?

Think of the battlefields of the 18th century: the noise of the weapons, the smoke and fire mingling with dust. In the midst of all this, it was hard to distinguish the emblems on the soldiers' helmets. At sea, the same problem arose: huge waves splashing salty spray, or rain, fog, fire and smoke . . . friend or enemy? Immediate recognition was a matter of life or death. A brightly colored flag could be seen from afar. The expression "hoist the colors," meaning "raise the flag," comes from this maritime tradition.

What are the most common colors in flags?

The colors linked to two heraldic metals, gold and silver, are frequently used, as well as primary colors in simple geometric shapes that enable easy recognition. Most flags are made up of primary colors. However, these colors do not always have the same meaning. Red is the most popular color, especially in Asia, Europe and South America. In the North and in Oceania, blue is the dominant color, and in Africa the favorite is green.

RED

Red, the color of life, blood, passion, danger, power, courage, revolution, liberty and decisiveness, is the most widespread color in national flags. In China, red is traditionally associated with good luck. It is by far the most patriotic color! Since the French Revolution (1789-1799), red flags have symbolized socialism, communism and leftist movements.

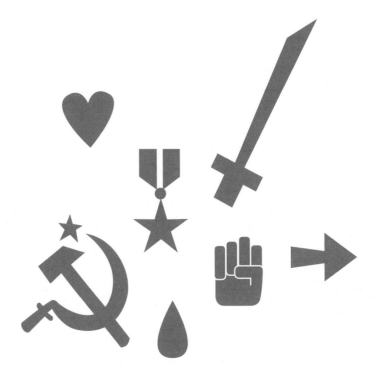

WHITE

The white flag is internationally recognized as the sign of truce. The side waving the white flag manifests its intent to surrender or negotiate. White indicates peace, innocence, unity, harmony and tranquility. It is also the color of purity. In nature it is embodied by the mountain and snow. In some countries, it is associated with death.

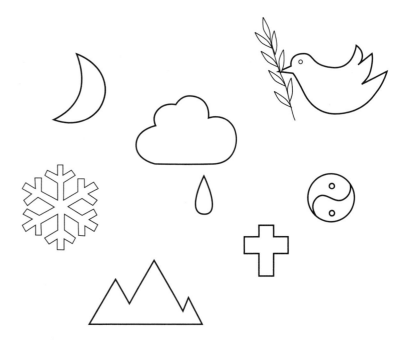

BLUE

Blue symbolizes water and sky, which are often associated with the infinite as well as wisdom, trust and harmony. It also evokes freedom, vigilance, perseverance, tranquility, calm, justice, prosperity and patriotism.

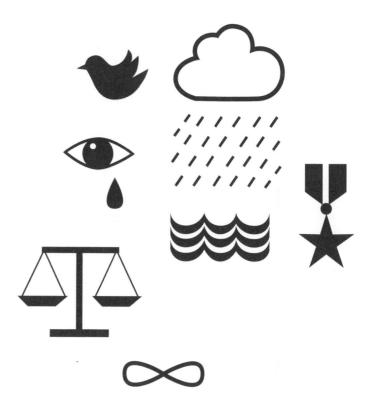

YELLOW

Yellow often evokes happines, energy, solidarity, power, gold, courage, sacrifice, generosity, the sun, the growth of plants and economic development. In China it is considered the imperial color. For Buddhists, it represents humility. In many cultures it may be associated with danger.

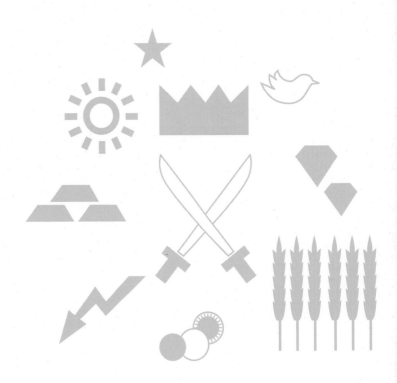

GREEN

Green stands for the earth, nature, rebirth, freshness and fertility, but also for peace, abundance, stability, agriculture, the jungle, hope of prosperity, solidarity. Green is also traditionally associated with Islam.

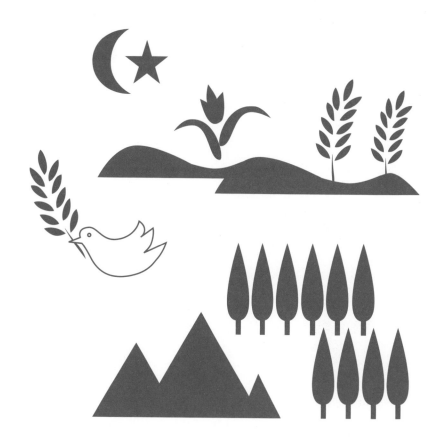

COMBINATIONS OF PRIMARY COLORS

The flag of Venezuela (p. 21) is the perfect example of meaningful color choice. General Francisco de Miranda, a Venezuelan revolutionary, himself designed it to represent the movement for independence. The use of primary colors was inspired by the great writer Goethe:

" . . . He proved to me why yellow is the warmest color, noble and closest to light; blue is that mix of excitement and serenity, a distance that evokes shadows; and red is the exaltation of yellow and blue, the synthesis, the vanishing of light into shadow. It is not that the world is made of yellows, blues and reds; it is that in this manner, as if in an infinite combination of these three colors, we human beings see it. . . A country starts out from a name and a flag, and it then becomes them, just as a man fulfills his destiny."

The Venezuelan flag inspired that of "Gran Colombia" and later the flags of Ecuador (p. 22) and Colombia (p. 23) when they become independent states.

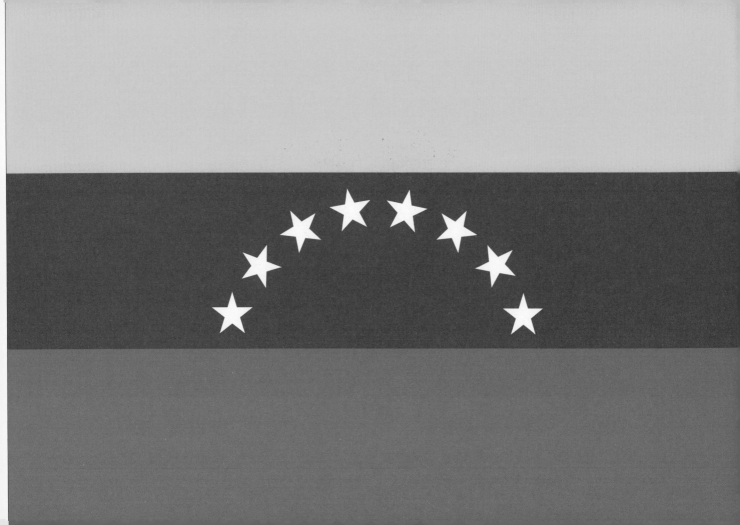

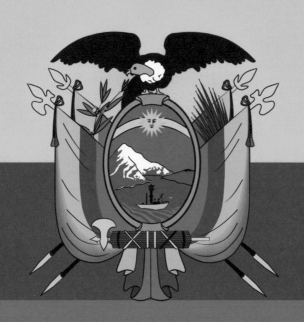

ORANGE

Orange evokes creativity, joy, enthusiasm and energy. It represents the earth, fertility and spirituality. It is associated with Buddhism and Hinduism.

BLACK

The Egyptians associate black with rebirth, while most cultures see it as evoking death, pain, mystery and anarchy. It also embodies determination, ethnic heritage and victory over the enemy.

PURPLE

Although red and blue are often seen on flags, their combination, purple, is rarely found. The color of meditation, purple brings to mind power and independence, but also passion and chance, extravagance, creativity, wisdom, dignity, peace, pride, royalty, mystery and magic.

BROWN

Like purple, brown is rarely used on flags. It is associated with the earth and nature. In some cultures, it is a symbol of humanity, humility and simplicity.

SHAPES

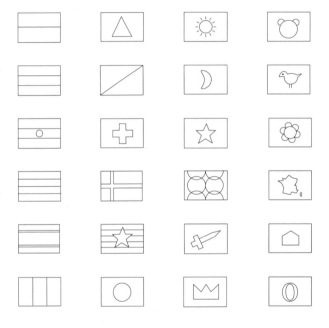

BANDS OF COLOR

The division of a flag into bands of color is quite common: horizontal or vertical, thick or thin, stripes and bands are found in more than a hundred flags. Most flags include bands, whether vertical or horizontal, of equal or unequal width, with or without symbols. Some 40 flags have 3 horizontal stripes of the same width, and more than 50 use 3 colors. It is this simplicity that makes tricolor flags recognizable from far away. Many flags started out as navigational emblems. The Republic of Holland was a top naval power in the 17th century, and its simple flag became the symbol of its wealth and power.

It inspired many others. The colors of the French flag that emerged from the Revolution (p. 95) were adopted by other countries: blue-white-red is the most frequently seen combination in the world, used in 30 flags.

TWO HORIZONTAL BANDS OF EQUAL WIDTH

There are a few bicolor flags with bands: Ukraine's (p. 29), Monaco's (p. 30) and Poland's (p. 34), for example. The flags of Madagascar (p. 277), Benin (p. 108) and Guinea-Bissau (p. 109) also have vertical bands on the sides. Those of Angola (p. 232), Burkina Faso (p. 114), Haiti (p. 274), Singapore (p. 33) and San Marino (p. 285) add symbols to the bands, and the Czech Republic (p. 35), Djibouti (p. 207) and the Philippines (p. 178) include triangles on the sides.

The Ukrainian flag presents a pastoral vision of the country: the golden yellow symbolizes wheat fields, while the blue embodies the sky, mountains and rivers. However, the roots of Ukraine's yellow and blue national symbols date back to a pre-Christian era when the colors symbolized fire and water.

The only
difference
between
these two
seemingly
identical
flags is in
their width.

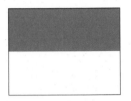

The red and white on the flag of Monaco (p. 30) have been the colors of the Grimaldi coat of arms* since 1339.

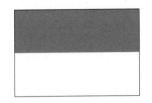

Indonesia's flag is called *Sang Saka Merah Putih* ("lofty bicolor red and white [flag]").

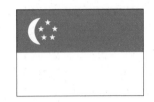

Singapore (p. 33) adopted its flag in 1959.

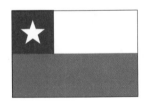

Chile (p. 161)

Poland (p. 34) adopted its flag in 1919, reusing the colors of 1831.

In 1920, a blue triangle was added to the Czechoslovakian flag, which had been identical to Poland's. It is now the flag of the Czech Republic (p. 35).

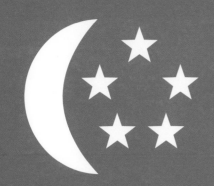

THREE HORIZONTAL BANDS AND TWO COLORS

RED-WHITE-RED

Numerous flags are composed of three horizontal bands of equal width.

One of the oldest is the flag of Austria (p. 38). It is said to have been inspired by the Duke of Babenberg's white shirt covered with blood after a battle against the Moors during the era of the Crusades. In the 18th century, it was adopted as a maritime flag, and in 1918 it was chosen as the national emblem.

The Latvian flag (p. 39) uses a different color of red, and the stripes are not equal, but its origin is nonetheless quite similar. A wounded chief of the Lett tribe wrapped himself in a white cloth. The part of the cloth where he lay remained white, while on either side it was stained with blood. During the ensuing battle, the cloth served as a flag. And this time, the Lett warriors drove off the enemy.

BLUE-WHITE-BLUE

This pattern is used by 5 neighboring countries: Honduras (p. 41), Nicaragua (p. 42), El Salvador (p. 43), Guatemala (p. 252) and Uruguay (p. 183). Their 5 flags are direct descendants of the flag of the United Provinces of Central America, an attempt to unify the region after the countries achieved independence from Spain, although the union lasted only 16 years. The strong resemblance to Argentina's flag (p. 182) is notable. The blue-white-blue triptych was the favored symbol of South American liberationist circles. After improvement in its relations with Spain, Guatemala changed the stripes on its flag to vertical ones.

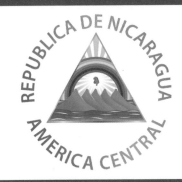

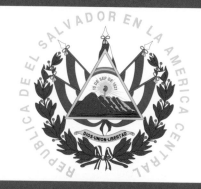

BLUE-WHITE-BLUE . . . AND RED

The flag of Costa Rica (p. 46), a former member of the United Provinces of Central America, was originally striped blue-white-blue with a coat of arms in the center. To make it distinctive, the blue stripes were made darker, and in 1848 a wide red band was added in homage to the French Revolution. The blue stands for the sky, opportunities to be seized, reflection, determination, the infinite, eternity and spiritual ideas. The white stands for clarity of thought, happiness, wisdom, power, the beauty of the sky and peace. The red represents the warmth of the Costa Rican people, their love of life, the avidity for freedom in their blood, and generosity.

Its resemblance to the flag of Thailand (p. 47) is stunning: the Thai flag is referred to as *Thong Trairong*, meaning "Tricolor." But it was not always thus.

Formerly, the flag was red with a white elephant. The historical take is that the king of Thailand—then known as Siam—had noticed that the national flag was flying upside down. This irritated him immensely, and he ordered a new, symmetrical flag to be created that could never be raised upside down.

Early on, it was a red flag with 2 white bands, but the middle band was changed to blue to represent the Thai monarchy and show the country's solidarity with the Allies in the First World War (Great Britain, France, the United States and Russia, whose flags are all blue-white-red).

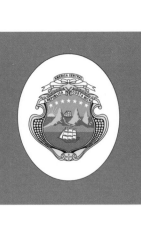

THREE HORIZONTAL BANDS OF EQUAL WIDTH

Some 40 flags have 3 equal-width horizontal stripes. This pattern, typical for its simplicity and visibility, originates as a ship's flag.

Luxembourg (p. 52) uses the same colors in its flag as the Netherlands (p. 51), but with a lighter blue. Hungary (p. 53) replaced the blue with green, the color of hope (with the red for strength and the white for faithfulness).

Bulgaria (p. 54) also uses three colors, including white, which evokes peace, love and freedom.

The yellow in the Lithuanian flag (p. 55) was added to the colors green and red found in the country's folk art.

The modern Russian flag (p. 56) is directly inspired by that of the Netherlands: in 1705, Czar Peter the Great ordered that commercial

Russian ships use a version slightly different from the latter. This was because the tricolor flag was simple, easily recognizable and less costly to produce. The czar and his government, of course, would not stand for people brandishing the old flag, which featured an eagle, an imperial symbol. In addition, anyone and everyone could make a white-blue-red flag!

While the Estonian flag (p. 57) evokes a pastoral landscape (a forest on a snowy day, with the sky overhead, the darker forest in the middle and the snow-covered land beneath), the flag of Gabon (p. 58) describes its geographic position: the yellow band stands for the Equator, which bisects the country, as well as the sun. The blue is the Atlantic Ocean and the green the luxuriant vegetation of the equatorial forest.

Sierra Leone's flag (p. 59) was created at the end of the 18th century to welcome freed slaves. The national motto, "Unity, Liberty and Justice," is evoked by the white color in the middle of the flag.

In Germany (p. 60), two rival traditions played an important role in the choice of flags: black-red-gold against black-white-red. The colors of the current flag are associated with republican democracy and embody unity and liberty.

Orange, for the people of Armenia (p. 61), represents their creative talent and hardworking nature.

TRICOLORS

The Netherlands has the oldest tricolor striped flag in the world. In the 9th century, under the reign of Charlemagne, this coastal territory was known by its blue, red and white colors. The leader of Holland's revolt was the Prince of Orange, nicknamed William the Silent. His orange-white-blue banner became the national flag around 1572. The most famous version, red-white-blue, gained dominance around 1630. After the French Revolution of 1789, the color combination red-white-blue became indicative of liberty and brought honor to the Netherlands, which had used them first.

In 1806, when Napoleon's brother, Louis, became regent of the Kingdom of Holland, he retained this flag. After independence, the new kingdom of the Netherlands reaffirmed the national colors by royal decree, in 1937.

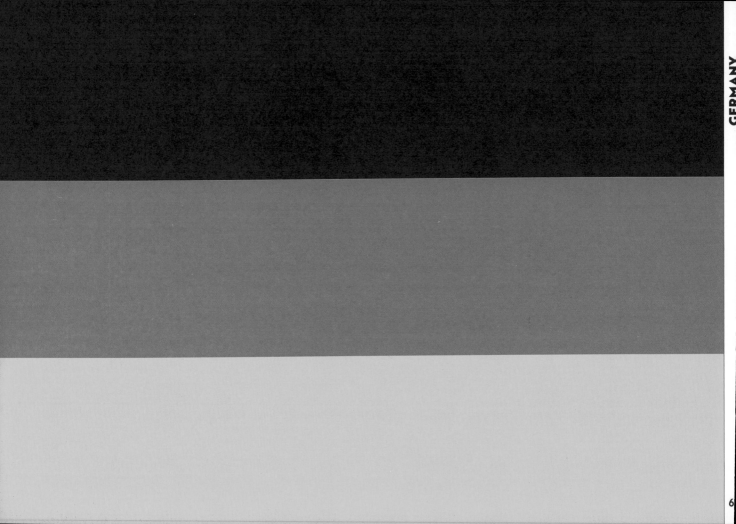

THREE HORIZONTAL BANDS OF EQUAL WIDTH, PLUS A SYMBOL

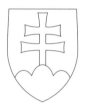 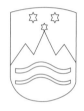

For greater specificity, flags may include drawings or symbols that appear on a background of color.

In the center of the white band in Lesotho's flag (p. 67), for example, is a black mokorotlo, a traditional hat in Lesotho.

The first pan-Slavic Congress in 1848 chose red, blue and white as its emblematic colors. Slovakia (p. 68) and Slovenia (p. 69) use the same colors, with an emblem on the left side of the flag.

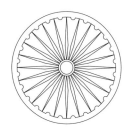

The Ashoka Chakra in the center of India's flag (p. 70) is the endless wheel of dharma — the cosmic order and law — and represents the teachings of Buddha.

The orange circle on the central stripe in the flag of Niger (p. 71) represents the sun and independence.

On the flag of Ghana (p. 72), the black star symbolizes African emancipation, while the white star partially covering the colored stripes on the flag of Myanmar (Burma) (p. 73) evokes a consolidated union.

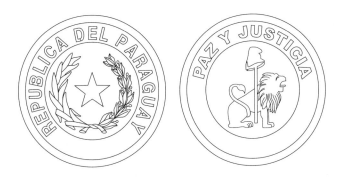

Paraguay's flag (pp. 65, 66) is the only one that has two different sides!

On one side is the coat of arms with the name of the Republic of Paraguay. On the other a lion is seen alongside the words *Paz y Justicia* ("Peace and Justice").

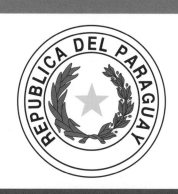

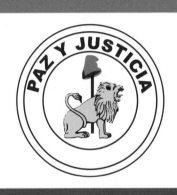

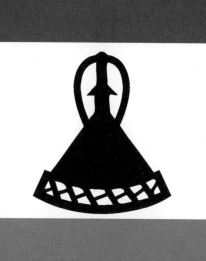

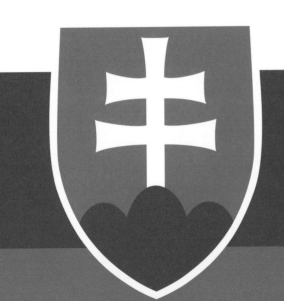

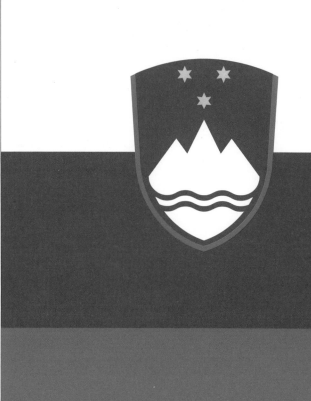

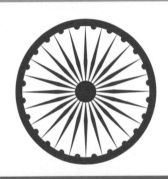

HORIZONTAL BANDS AND STRIPES IN PAN-ARAB COLORS

The pan-Arab colors were inspired by the verses of a 14th-century Iraqi poet, Safī al-Dīn al-Hilli: "We, the Arabs, are the people whom honor forbids to do harm to those who do not harm us. Our acts are white, our battles are black, our fields are green and our swords are red."

This poem influenced new movements. The combination white-black-green-red was first used during the Arab rebellion against the Ottoman Empire in 1916. The flag of this rebellion inspired many Arab countries, but the flags of Palestine (p. 78) and Jordan (p. 79) are the closest to it.

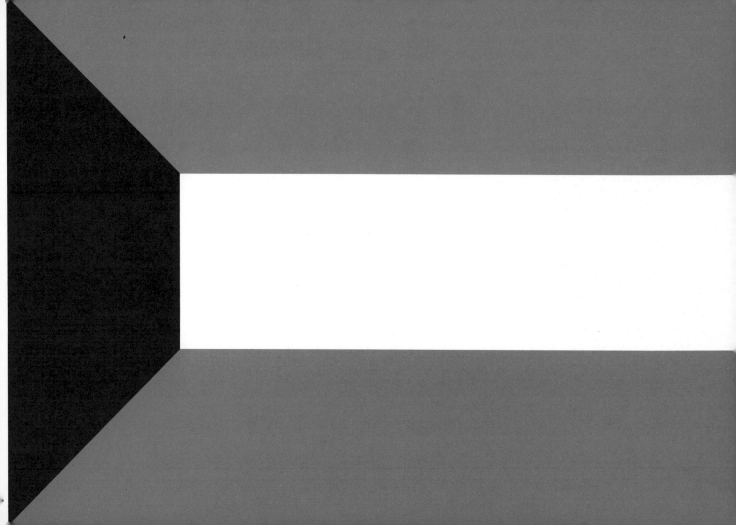

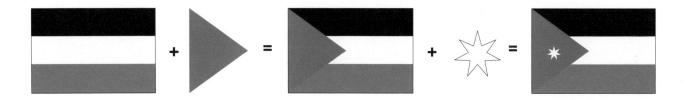

Under the British mandate in Palestine, Transjordan was a semi-autonomous region. Its flag was composed of the banner of the Arab movement with the addition of a triangle that represented the Hashemite dynasty. When Jordan became autonomous in 1928, it added the 7-pointed star to symbolize the first 7 verses of the Koran and the 7 hills on which the country's capital, Amman, was founded.

In 1964, the Palestinian people went back to the initial emblem of Transjordan to symbolize its liberation. Due to the proximity and shared history of Palestine and Jordan, their flags are very similar.

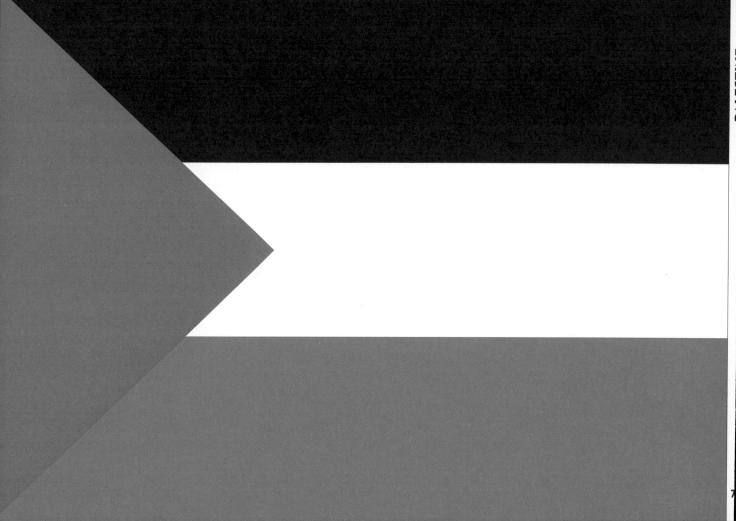

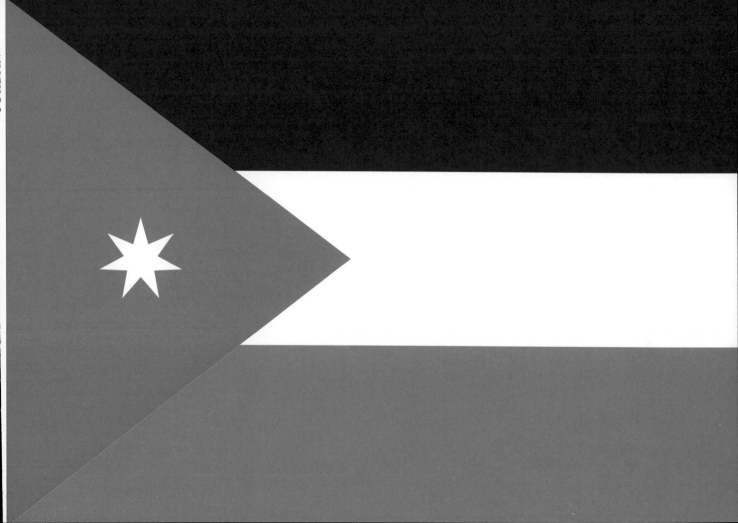

+ = **EGYPT**

+ ★ ★ = **SYRIA**

+ = **SUDAN**

+ الله اكبر = **IRAQ**

Three horizontal stripes plus a triangle
(see also Bahamas, p. 124).

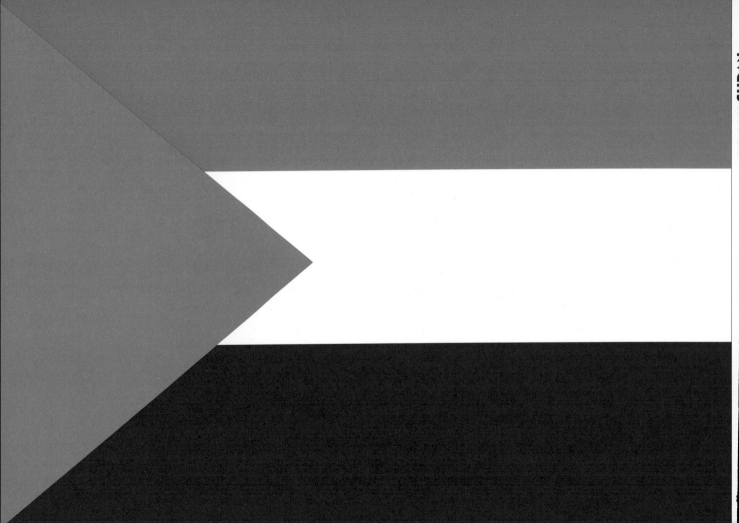

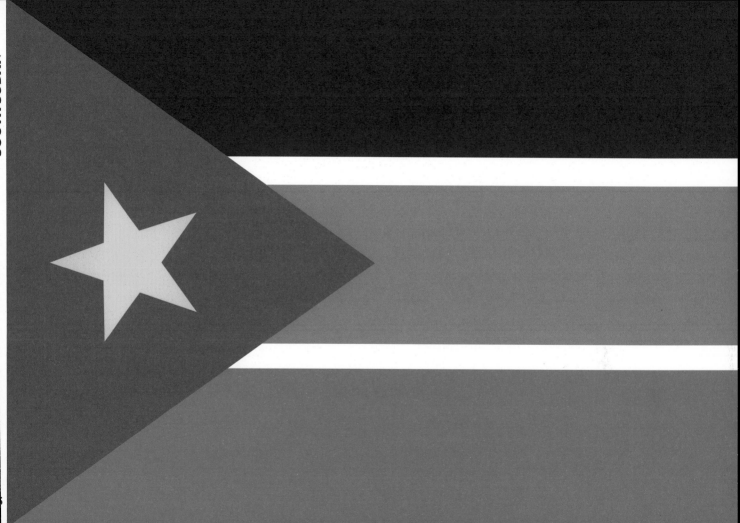

FOUR HORIZONTAL STRIPES OF EQUAL WIDTH

The flag of the Republic of Mauritius (p. 87) is the only one to have 4 unadorned horizontal stripes of different colors: red for freedom and independence, blue for the Indian Ocean where the island lies, yellow for the light of independence and green for agriculture.

The Comoros flag (p. 88) features 4 stripes that symbolize the 4 islands in the archipelago: yellow (Mohéli), white (Mayotte, a French protectorate that became an overseas department in 2009), red (Anjouan) and blue (Grande Comore).

The flag of the Central African Republic (p. 89) was created by its first prime minister, Barthélemy Boganda. Its design symbolically expresses his conviction that France and Africa must move forward together. It mingles the blue and white of the French flag with the yellow and green colors of Africa, uniting them with a vertical red stripe. The yellow star at the upper left evokes independence.

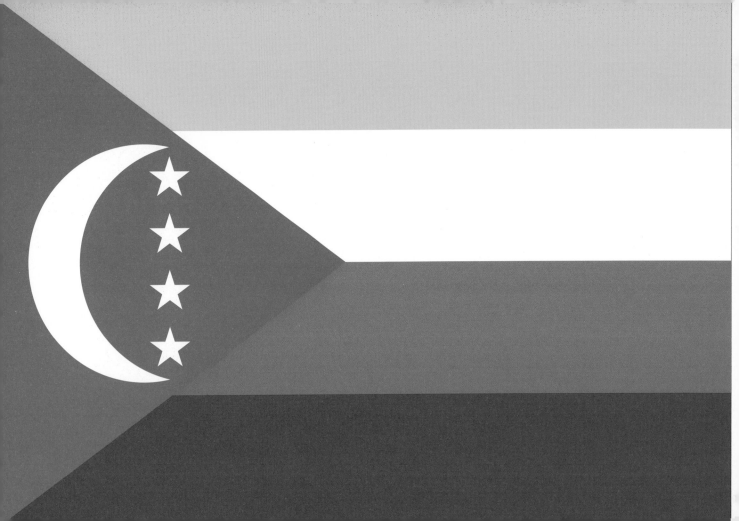

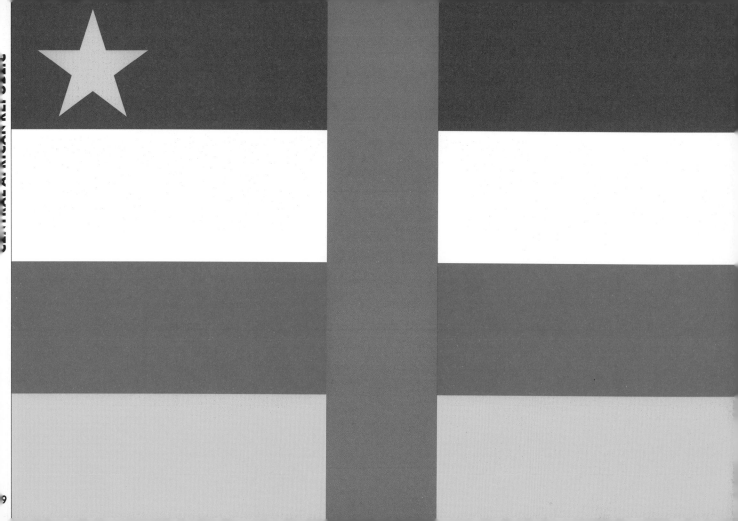

BORDERS

These narrow stripes, white or colored, outline the main colors to make them stand out. Separating dark colors with white or yellow enhances their visibility. The use of these accent borders in heraldry and vexillology is called fimbriation, derived from the Latin word *fimbriatus*, meaning "fringed." More than 20 countries use this method on their flags. The most famous may be that of the United Kingdom (p. 153), but it is also seen in the flags of South Africa (p. 135), Trinidad and Tobago (p. 133), North Korea (p. 216), Suriname (p. 205), Swaziland (p. 231), Kenya (p. 230) and even more.

Botswana's (p. 92) is one of the rare African flags that does not use pan-African colors. The blue above stands for water, a precious resource. The white and the black symbolize equality and harmony in a mixed population — or do they refer to the stripes of the zebra, its national animal?

The flag of Gambia (p. 93) is an example of a tricolor with borders: the upper stripe is red, for the sun and the country's position on the Equator; blue is for the Gambia River; and green is for forests and agriculture.

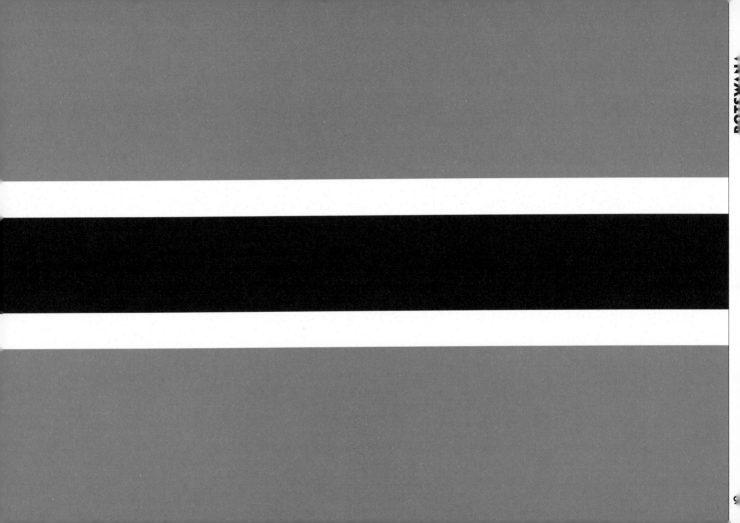

THREE VERTICAL STRIPES

WHITE MIDDLE STRIPE

The French flag (p. 95) appeared during the Revolution, first as a cockade, and was officially made a standard in October 1790, then a flag in 1793. It adopted the historical colors of the French monarchy. Blue and red are also the colors of the city of Paris, where the principal events of the Revolution took place.

The flag of Italy (p. 96), *il Tricolore*, is very close, but with green instead of blue. In this case the red and the white were inherited from the flag of Milan, and the green stands for the country's military might.

In Ireland (p. 99), green is the color of the Catholic population, orange is the color of the Protestants and white stands for peace between the two religions.

The flag of the Ivory Coast (p. 98) has the same colors but in reverse order.

Nigeria's green-white-green flag (p. 97) was designed in 1959 by a student for a contest.

YELLOW MIDDLE STRIPE

The colors of the Belgian flag — black-yellow-red — are from the coat of arms of the Duchy of Brabant: a golden lion with red claws and tongue against a black background.

The choice of vertical stripes may have been inspired by France's flag (p. 95).

The flags of Romania (p. 103) and Chad (p. 102) are very similar. The only difference between them is the tones of blue. Romania's once featured a coat of arms, but this was eliminated in 1989 after the fall of the communist government. In the meantime, Chad had created its own flag. In 2004, Chad asked the United Nations to rule on the question of the duplicate flags, but Romania's president insisted: "The tricolor flag belongs to us, and we shall not renounce it."

Mali (p. 104) and Guinea (p. 105) kept the pan-African colors throughout tumultuous times.

The Malian flag had shown a human figure in the middle, but it was eliminated out of respect for Muslims.

RASTA

Ethiopia (p. 107), one of the oldest independent states in Africa, was considered a model for emerging African countries in the 1950s and 1960s. Its colors embody African independence and unity; they are the origin of the pan-African colors, also called "Rasta colors." Ethiopia wished to reproduce the colors of the rainbow created by God after the flood from the book of Genesis. They may be interpreted as a reference to the Holy Trinity, but also to the country's 3 main provinces.

The blue disk stands for peace, the star for the unity of people and races, and the 5 stripes for prosperity.

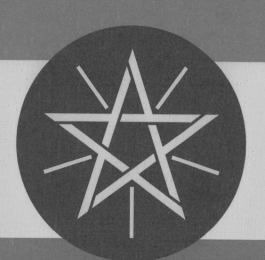

BENIN

TRIANGLES

The triangle often symbolizes strength and power.

In Christianity, the 3 points indicate the Trinity: the Father, the Son and the Holy Spirit.

The 5 white triangles on the flag of Bahrain (p. 118) stand for the 5 pillars of Islam.

There are 9 in the Qatari flag (p. 119); the country was the ninth member of the former Trucial States, a British protectorate that ended in 1971.

The yellow triangle on the flag of Bosnia and Herzegovina (p. 120) evokes the country's shape.

On the flag of Saint Lucia (p. 121) the black and yellow triangles depict the twin volcanoes called the Pitons.

The Eritrean flag (p. 122) is composed of 3 triangles, while that of Guyana (called Golden Arrowhead, p. 123) has one more.

On the flag of the Bahamas (p. 124) and that of East Timor (p. 125), the black triangle stands for the power of the people.

Flags are generally distinguished by colors and symbols. One is unique for its shape: did you know that the flag of Nepal (p. 117) is the only one in the world that is neither square nor rectangular? In fact, a manual had to be created with geometric instructions on how to reproduce it!

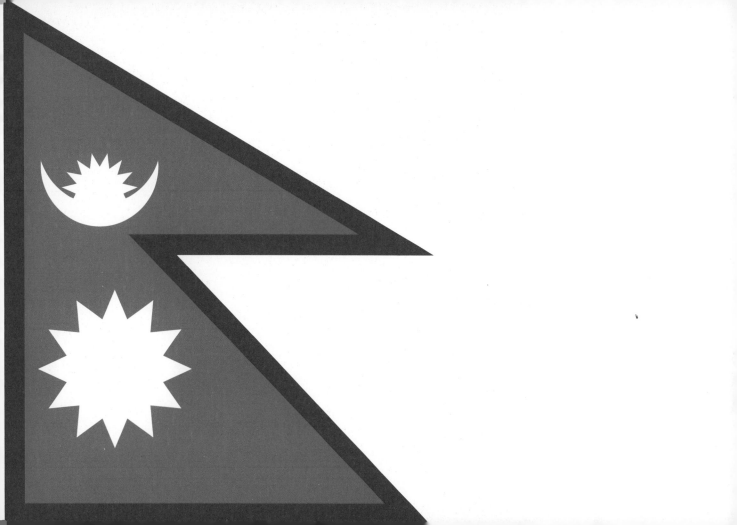

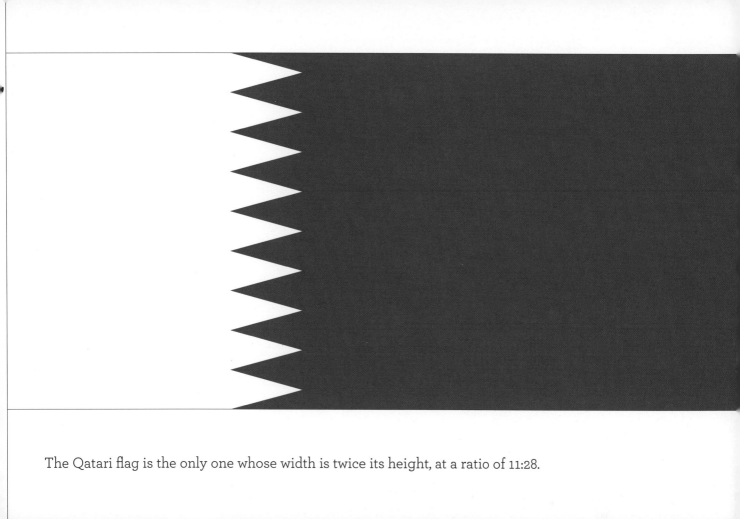

The Qatari flag is the only one whose width is twice its height, at a ratio of 11:28.

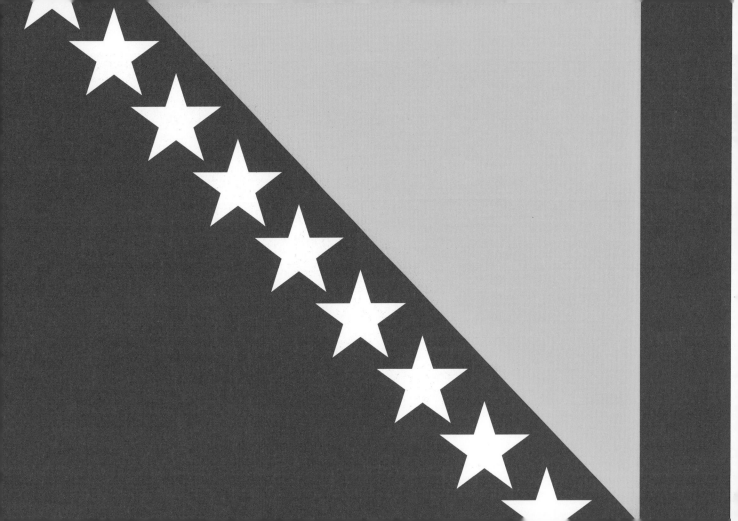

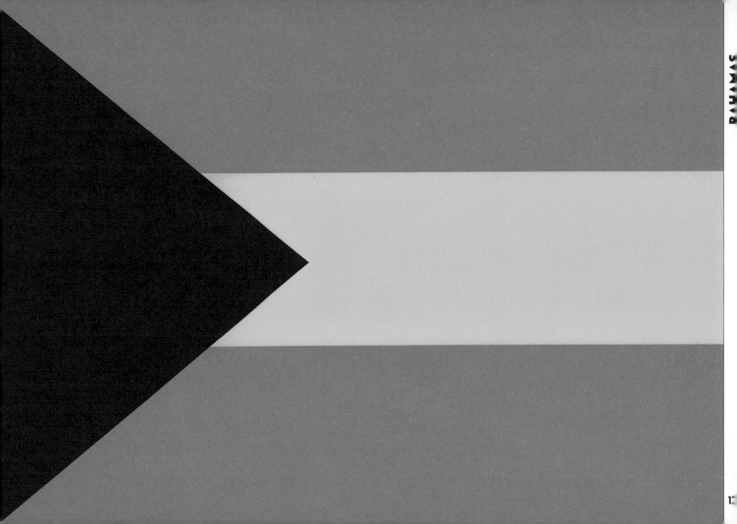

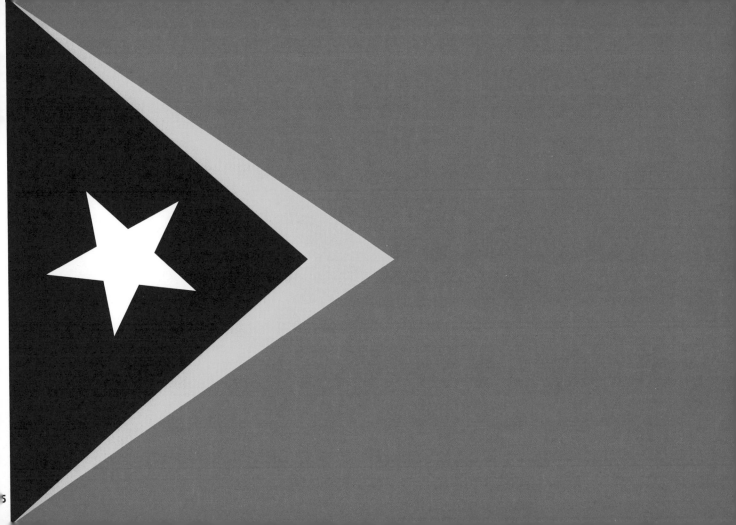

DIAGONALS

 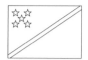

A diagonal provides an element of dynamism and force. It is used in various ways.

The flag of Bhutan (p. 246) and the flag of Papua New Guinea (p. 255) are divided in two by diagonals.

The Marshall Islands (p. 219), Namibia (p. 184), Congo (p. 115) and Brunei (p. 291) also have flags divided by one or even several diagonals.

In the Solomon Islands' flag (p. 130), the natural environment is depicted on the flag: yellow represents the sun and its rays, separating the earth (green) and the ocean (blue).

The Tanzanian flag (p. 131) is the result of combining two flags, that of Tanganyika and that of Zanzibar, when they united to become a single nation.

The diagonals in the flag of Saint Kitts and Nevis (p. 132) create a green triangle (fertility) and a red one that symbolizes the fights to liberate slaves and defeat colonialism.

The black, white and red of the Trinidad and Tobago flag (p. 133) are associated with earth, water and fire, but also evoke the country's past, present and future.

A yellow Y on Vanuatu's flag (p. 134) suggests the positions of the islands that make up the country. The same shape on South Africa's flag (p. 135) indicates the convergence of paths in the country's history and present political realities.

When two diagonals form an X, it is called a Saint Andrew's cross. This is seen on the flag of Jamaica (p. 136) where "the sun shines, the earth is green and the people are strong and creative."

The white Saint Andrew's cross on Burundi's flag (p. 137) stands for peace.

The Seychelles (p. 129) is an archipelago of 115 islands named after Louis XV's minister of finance, Jean Moreau de Séchelles. Its flag design consists of 5 radiating bands in blue, yellow, red, white and green, that emerge from the lower left corner. The rays are the image of a young, dynamic country marching toward its future. Blue is for the sky and the sea, yellow for the sun that brings life and light, red for the determination of its people to work hard, white for social justice and harmony and green stands for the earth and nature.

Each of the colors also corresponds to one of the Seychelles' political parties.

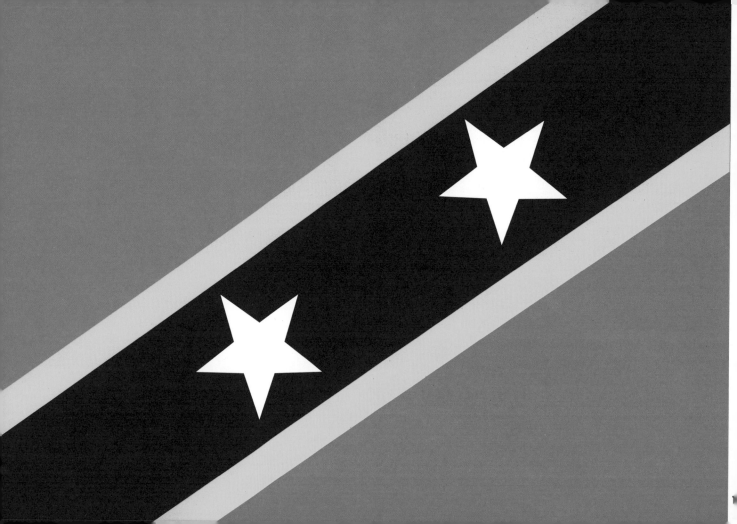

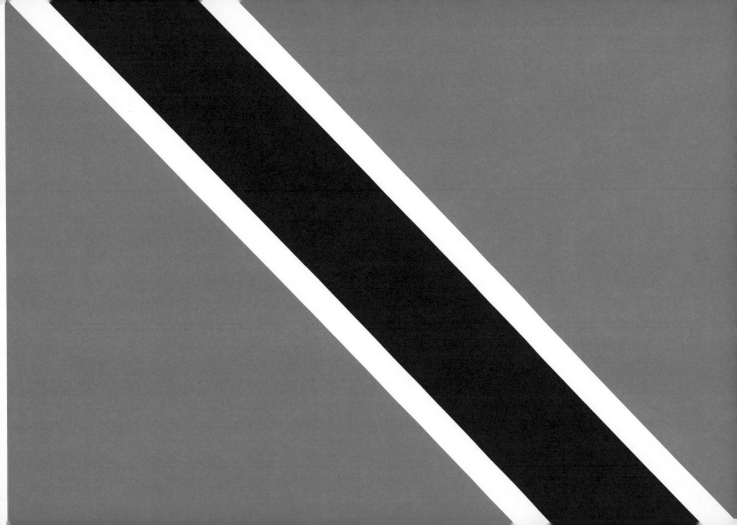

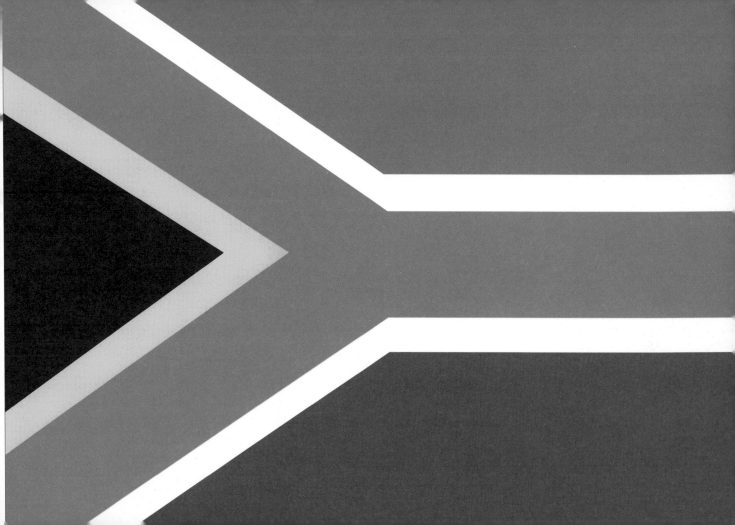

CROSSES

 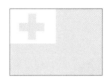

Before the 6th century CE, the cross was simply a representation of the cardinal points of the compass. However, in the 6th century it began to be considered a symbol of the Christian faith.

More than 60 countries have included religious signs in their flags.

The Swiss flag (p. 141) is red with an equilateral cross in the center, though the first national Swiss flag was a tricolor of green-red-yellow.

The former flag of Tonga showed a red cross on a white background, but it was practically identical to that of the Red Cross, which was created in Switzerland and whose flag looks like the Tongan cross upside down. For this reason, Tonga placed the cross in the upper left corner of its flag (p. 140).

The flag of Georgia is also called the "five-cross flag" (p. 142). The George Cross is repeated on it four times; it appears only once on the Maltese flag (p. 143), with the inscription "For Gallantry," a motto bestowed upon Malta by the British in honor of its heroism during the Second World War.

Founder Juan Pablo Duarte was the creator of the Dominican flag (p. 144). A white cross (for health) divides it into 4 rectangles: 2 blue (for liberty) and 2 red (for its heroes' blood).

Greece, a country bathed in ocean, has a flag especially well suited to it. In Greek it is called *I Galanolefki* (p. 145), meaning "The Blue and White." The cross against a blue background evokes Christianity.

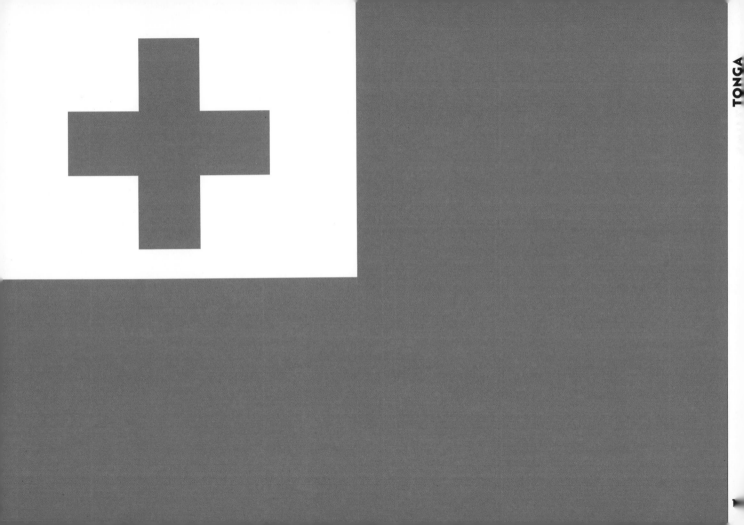

TONGA

The Swiss flag is one of only two square flags belonging to sovereign states (the other being that of the Vatican, p. 239).

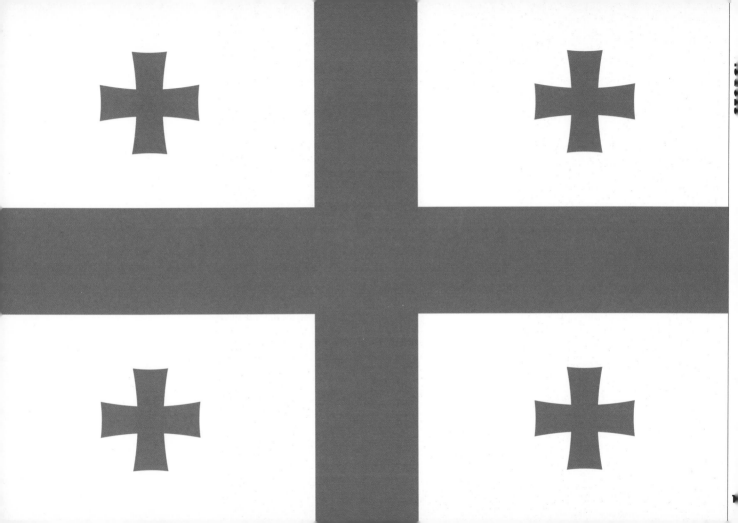

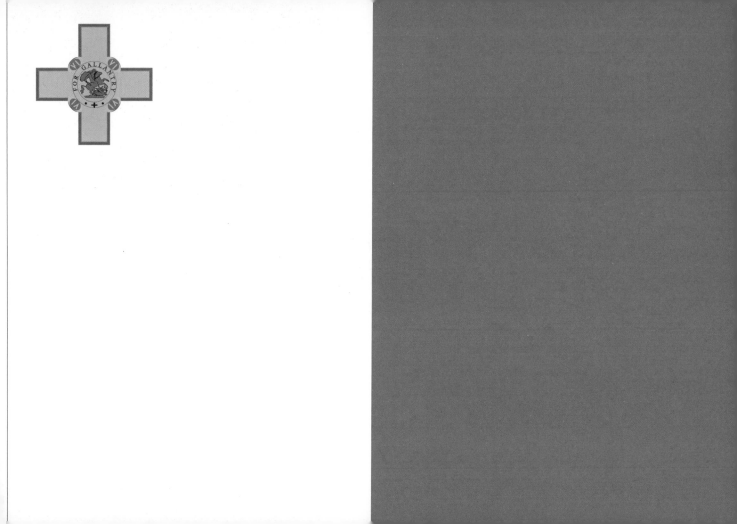

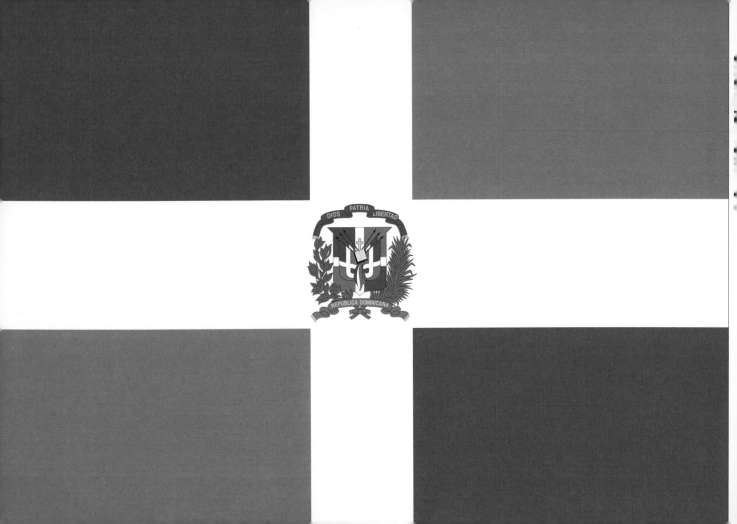

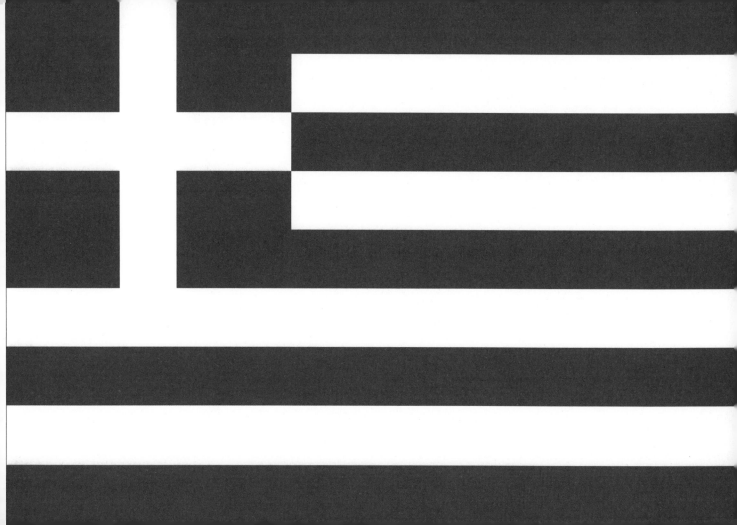

SCANDINAVIAN CROSS

According to legend, the Danish flag (p. 147) had its origin in a vision King Valdemar II of Denmark had of a white cross in the sky, before the battle of Lyndanisse in 1219.

The red background represents sundown as night falls. The off-center cross comes from maritime flags, for easy recognition at sea. Denmark's flag, the Dannebrog, is the oldest flag in the world. It inspired the flags of other Nordic countries.

Norway (p. 148) was administered by Denmark from the middle of the 15th century until 1814; it then united with Sweden until 1905.

The blue cross stands for this union.

The reverse version on the flag of Iceland (p. 149) reflects its ancestral ties to Norway.

The colors of Sweden (p. 150), a yellow cross on a blue background, come from the Swedish coat of arms, composed of 3 yellow crowns on a blue background.

Finland's flag (p. 151) evokes the blue of its lakes and the white of snow.

UNION JACK

After the death of Queen Elizabeth I in 1603, King James VI of Scotland was called upon to rule England. The crosses that represented each country were united in one flag. The third cross represents Ireland and was added in 1801.

In the following pages we see four former British colonies that have become independent and incorporated the Union Jack in the upper left-hand corner of their flags.

Saint George's cross (England)

Saint Andrew's cross (Scotland)

Saint Patrick's cross (Ireland)

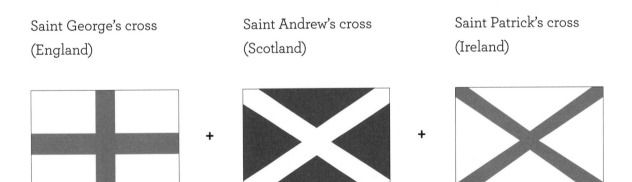

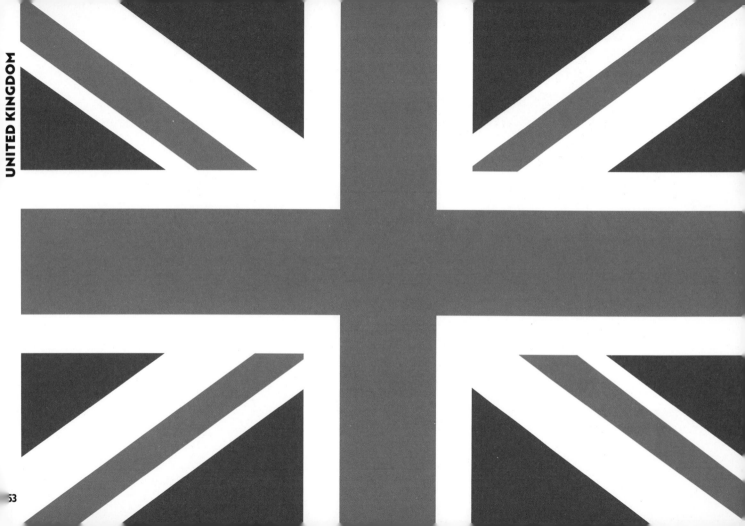

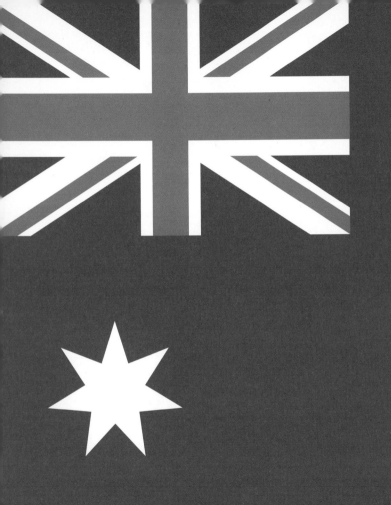

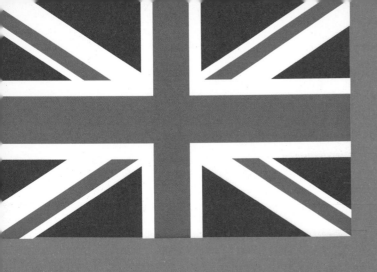

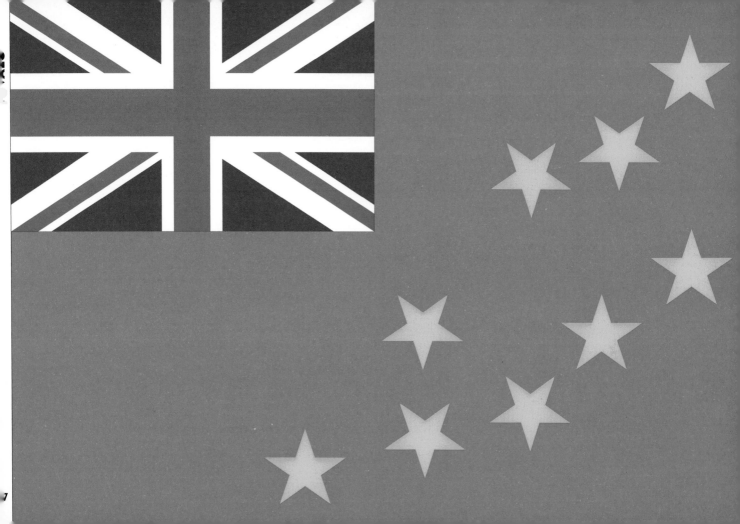

STARS & STRIPES

The flag of the United States (p. 159), also known as Old Glory, is composed of stars and stripes. The first 13 states of the Union had formerly been British colonies, which explains why their colors are identical to those of the Union Jack.

Several nations have imitated this flag to express their closeness to the United States or the American Revolution.

The Liberian flag, called the "Lone Star" (p. 160), has 11 stripes, which stand for the 11 signers of the Declaration of Independence of Liberia, the country of freed slaves. The 5-pointed white star stands for the first independent republic on the African continent.

The Chilean flag, *La Estrella Solitaria* ("The Lone Star," p. 161), is one of the oldest flags in the world. It was adopted in 1817.

The 3 blue stripes of the Cuban flag (p. 162) symbolize its 3 original provinces.

The flag of Puerto Rico (p. 163), the reverse of Cuba's, cannot be raised without the United States flag flying next to it.

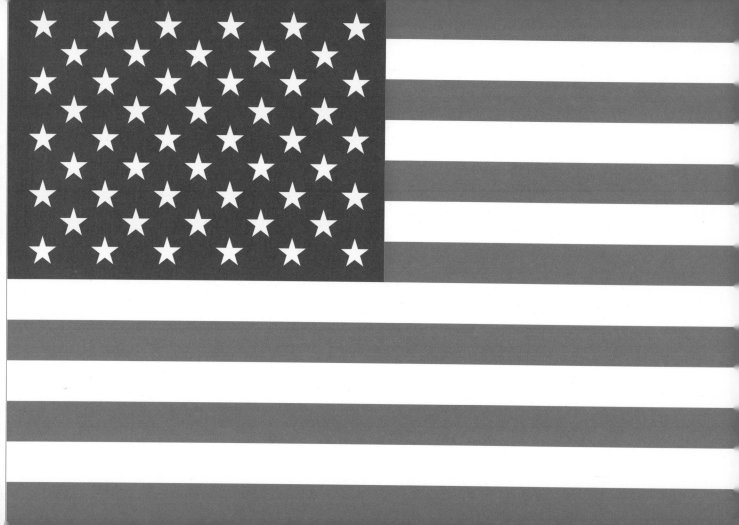

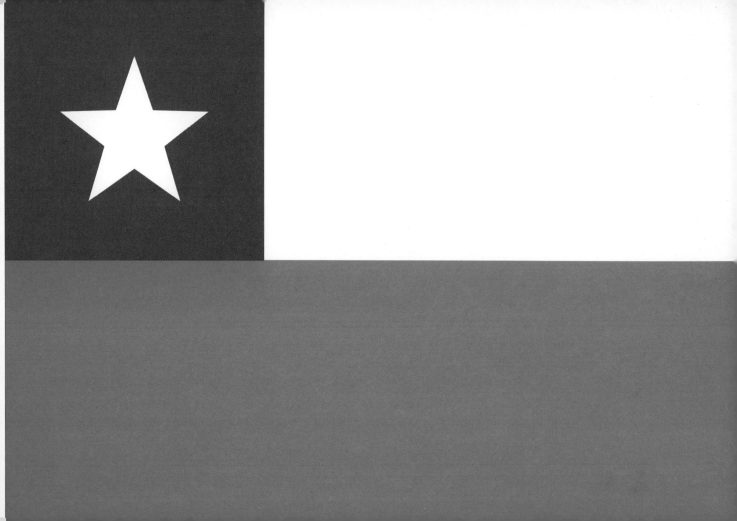

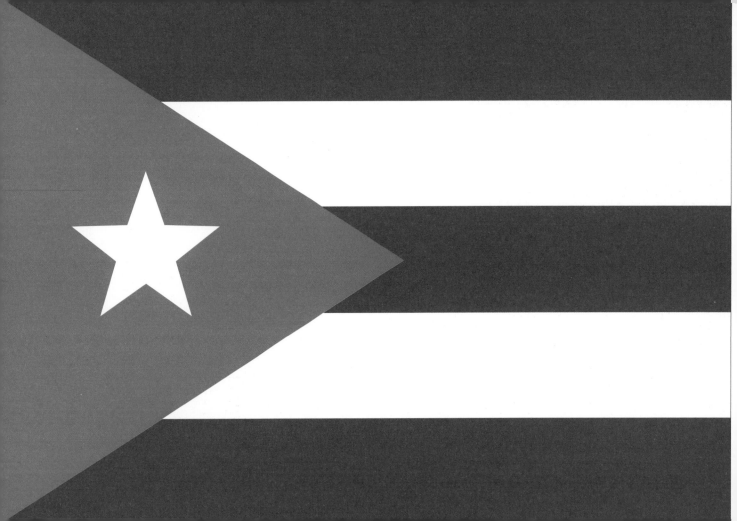

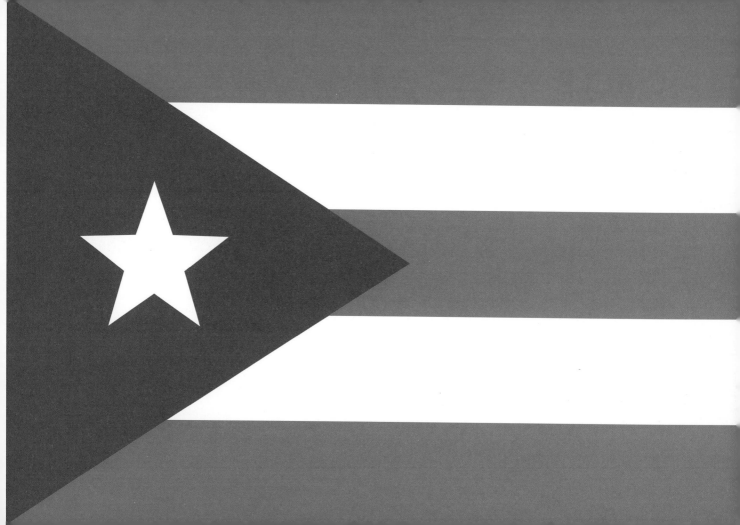

CIRCLE

In Japan (p. 165), the nation's emperor is considered the "Son of the Sun." The archipelago is also called "The Land of the Rising Sun."

Its flag appeared more than 1,000 years ago, but it was not until 1870 that Japan adopted it as its national emblem.

In Bangladesh, as well, the red circle embodies the rising sun, and through it, unity and energy (p. 166). The yellow circle on the flag of Palau (p. 167) and the white one on the flag of Laos (p. 168) are representations of a full moon, which has special significance in the local cultures.

The philosophy of yin and yang seen in the South Korean flag (p. 169) evokes the balance of the universe, with its opposite aspects: the 4 *kwae* (trigrams) stand for the 4 elements (air, earth, water and fire). This flag is known as *Taegukki*, which means "The Great Extremes."

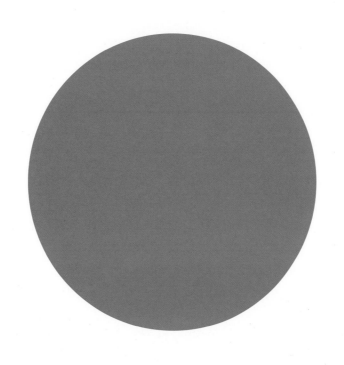

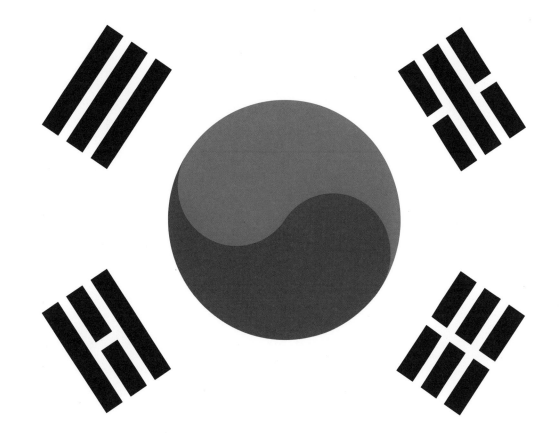

SOUTH KOREA

69

SUN

The sun appears on numerous flags, sometimes in abstract form. It evokes unity, light and the clarity that enlightens ignorance.

A yellow sun (peace and prosperity) with 40 rays represents the 40 Kyrgyz tribes, and in the center is a stylized version of the *tündük*, the central cap or crown of a yurt (the traditional tent). This stands for the family home and the universe at the same time, the theme of Kyrgyzstan's flag (p. 174).

The Macedonian national anthem proclaims: "Today, in Macedonia, the new sun of liberty is born. Macedonians are fighting for their rights!" (p. 175). The design of the sun is a simplified version of the star of Vergina that was seen on the previous flag of North Macedonia.

On the Kazakh flag (p. 176), the sun appears as the source of life and energy. It is also a symbol of wealth and abundance. The 32 rays are shaped like seeds ready to grow and prosper.

The yellow sun that as of 2001 shines on the flag of Rwanda (p. 177) represents light. Yellow is the symbol of economic development. Green evokes prosperity, and blue happiness and peace.

The yellow-gold sun on the Philippines' flag (p. 178) has 8 rays that stand for the 8 provinces. It is the only flag that changes when the country is at war. In that case, it must be flown backward.

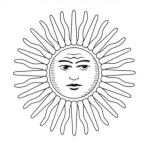

Blue sky, white sun and a field of red earth make up the flag of Taiwan (p. 179). The 12 rays of the sun are the 12 months of the year and the 12 traditional Chinese hours (each ray the equivalent of 2 hours).

The rising sun on the flag of Antigua and Barbuda (p. 181) depicts the dawn of a new era.

The 17 rays of the Kiribati flag (p. 180) embody the 16 Gilbert Islands and Banaba Island (formerly Ocean Island).

The "May Sun" (*Sol de Mayo*) on the Argentine flag (p. 182) celebrates the sudden glimpse of the solar disk through the clouds on May 25, 1810, during the first mass demonstration in favor of the country's independence.

The sun's traits are the same as those of Inti, the sun god of the Incas.

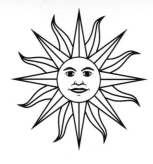

Uruguay's flag (p. 183) features 9 stripes. Within a white rectangle, the May Sun sends out 16 stylized rays, in alternating triangular and curved shapes.

The flag of Namibia (p. 184) was adopted on March 21, 1990, the day the country achieved independence. The 12-pointed golden sun evokes life and energy.

When Malawi adopted its flag (p. 185) in 1964, many African countries were regaining their independence. The rising sun embodies a dawn of hope and freedom on the continent.

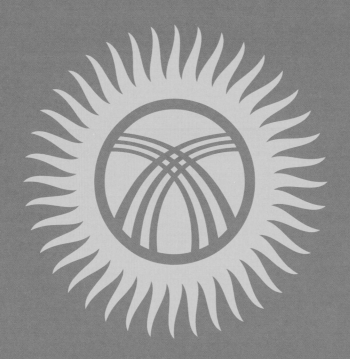

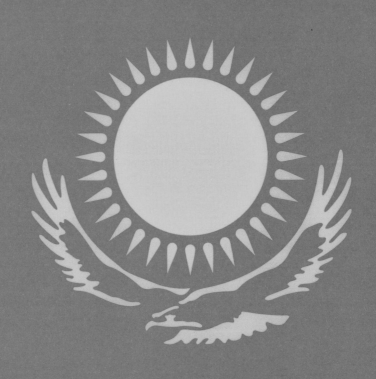

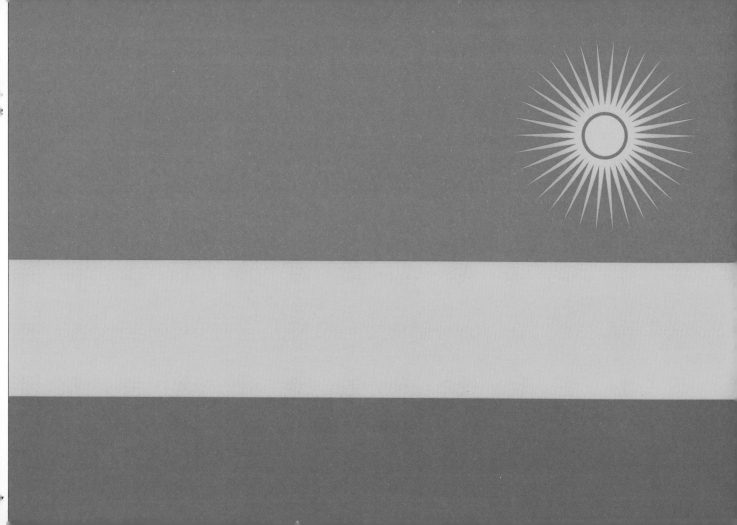

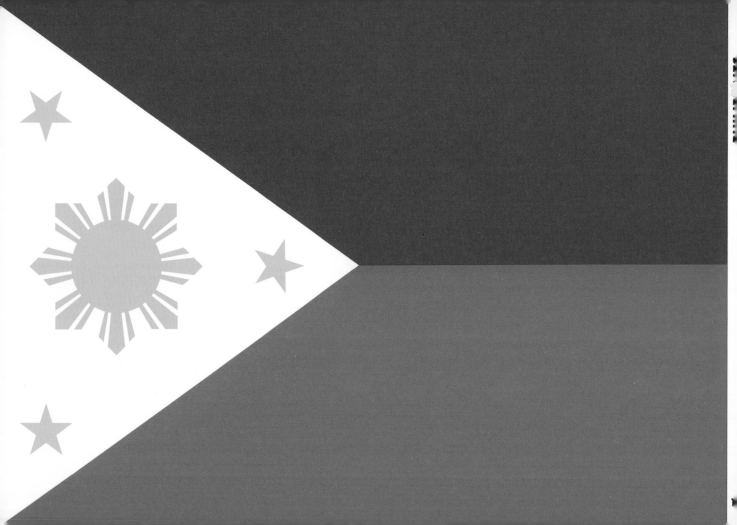

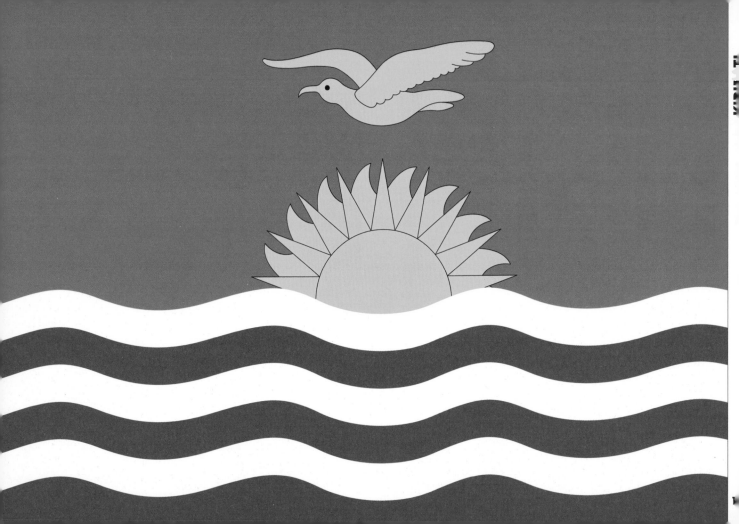

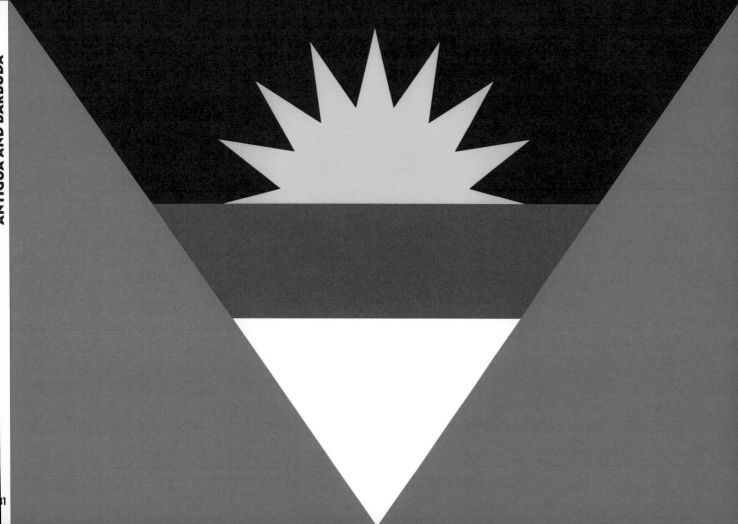

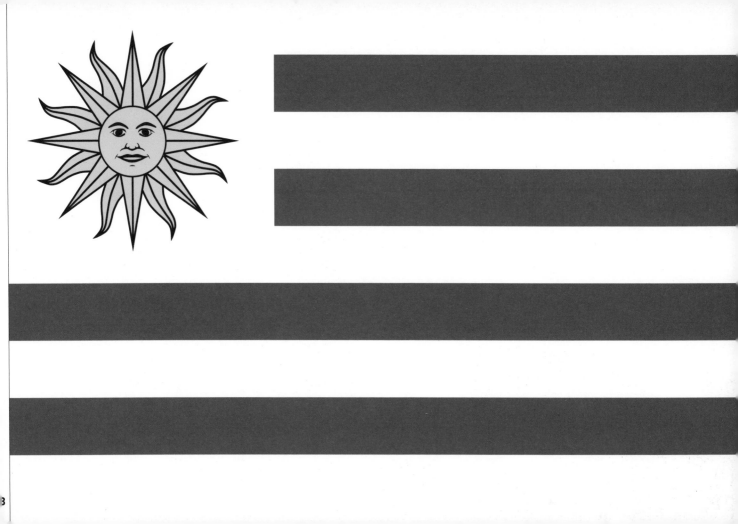

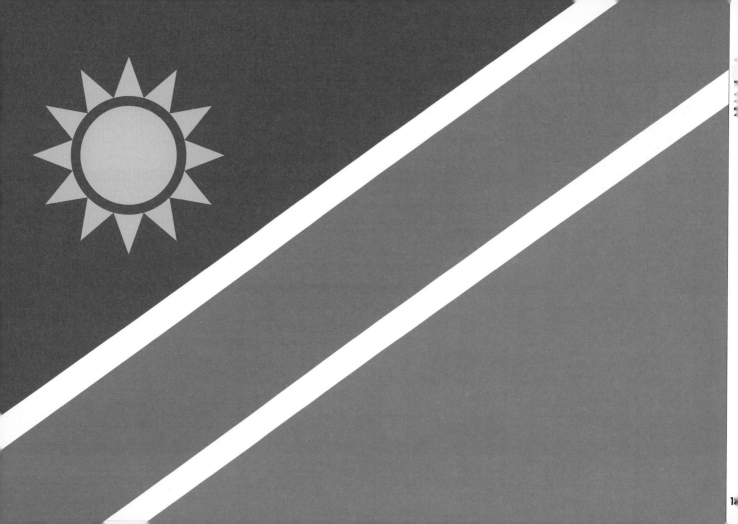

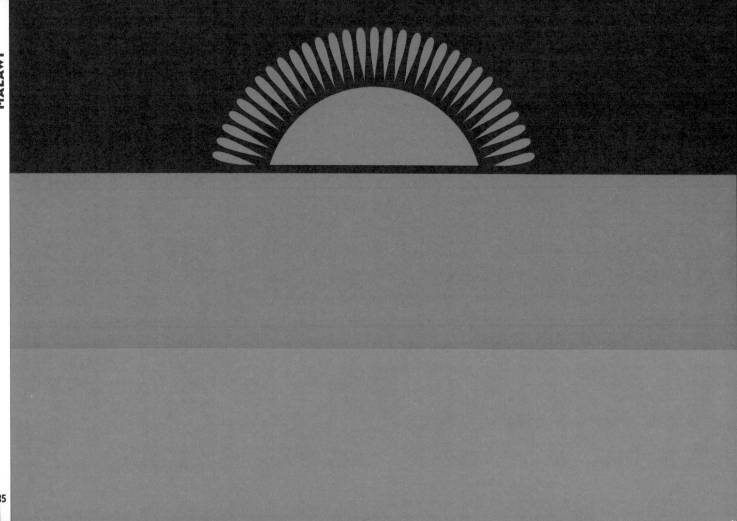

MOON

 —

The moon is generally depicted in its crescent form to distinguish it from the sun symbol. When accompanied by a star, it represents the divine, as well as Islam.

The Turkish flag (p. 190), similar to the last flag of the Ottoman Empire, inspired the flags of numerous other Muslim nations. It was during the Ottoman era that the crescent moon came to be associated with Islam.

The Tunisian flag (p. 191) shows a crescent moon and a 5-pointed star, both within a white disk embodying the sun.

The green, gold and red of Mauritania's flag (p. 192) are the pan-African colors. The gold also evokes the sands of the Sahara desert. The red stripes were added after a 2017 referendum and stand for the efforts and sacrifices of the Mauritanian people.

The red field of the flag of the Maldives (p. 193) is the symbol of the bravery of the country's national heroes. The green evokes peace and prosperity for the people. The white crescent corresponds both to Islam and to tradition.

The same colors are seen on the Algerian flag (p. 194), also associated with Islam.

The vertical white stripe on the flag of Pakistan (p. 195) stands for the country's minority religious groups.

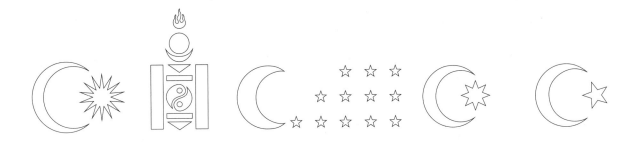

The yellow color of the crescent and star on the flag of Malaysia (p. 196), with a design inspired by the United States flag (p. 159), is the color associated with the ruling family.

The flag of Mongolia (p. 197) includes a stylized representation of fire, the sun, the moon, the earth, water and the symbol for yin and yang.

The crescent moon on the Uzbek flag (p. 198) evokes the rebirth of Uzbekistan as an independent republic more than its religion.

The flag of Azerbaijan (p. 199) was formally adopted in 1991, but had already been in use from 1918 to 1920.

The crescent on the Libyan flag (p. 189) symbolizes the start of the lunar month. It calls to mind the history of the hegira (migration) of the prophet Muhammad to spread Islam and preach the principles of virtue and kindness.

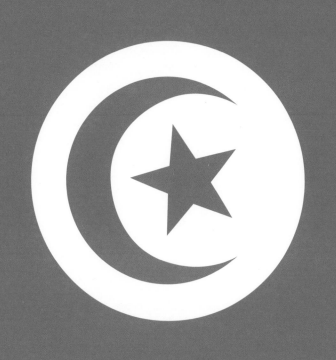

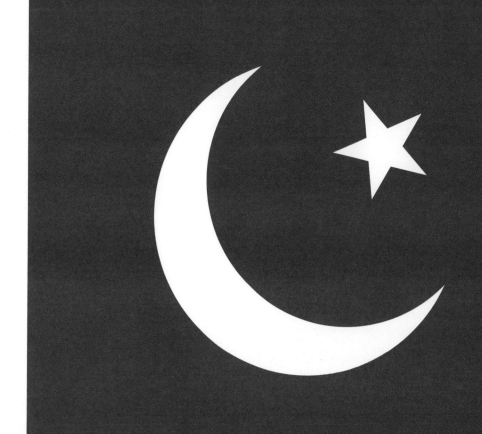

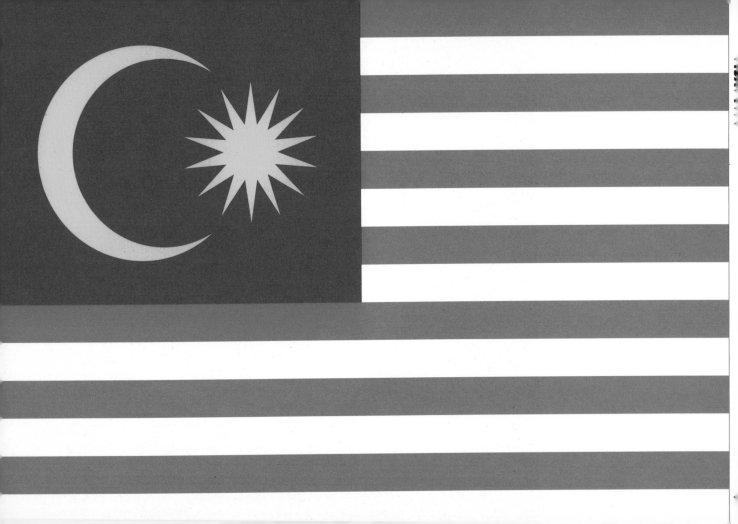

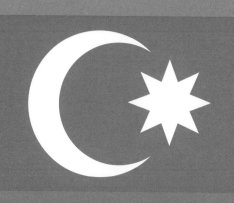

STARS

Stars are also considered heavenly symbols, and as such are used, in totally opposite ways, by communist ideology and by various religious groups. The star has been a symbol of independence and sovereignty since its appearance on the United States flag (p. 159), the Stars and Stripes, in 1777.

Grenada is divided into 6 regions symbolized by the 6 stars in horizontal rows on its flag (p. 204).

Suriname is a highly multicultural country: the star in the center of its flag stands for the unity of all its peoples (p. 205).

Unity is one of the interpretations of the star on the Democratic Republic of Congo's flag (p. 206) as well as Djibouti's (p. 207).

Solomon's Seal (*Khatam Sulaiman*) endowed the king with the power to command demons and genies, and made him the sole person who could speak with animals. Given the proverbial wisdom of Solomon, son of David, his signet ring was considered a talisman or symbol of magic; Morocco adopted the seal on its flag (p. 208), first with 6 points, then in a version with 5 points.

The 6-point version is better known as the Star of David (*Magen David*) in the Jewish tradition. As with Solomon's Seal, the earliest use of this symbol was an inheritance from the cabalists of medieval Jewish literature; it appeared on pendants worn as protective talismans. Later, the symbol came to represent Judaism and Zionism, and today it occupies the center of the Israeli flag (p. 209).

"Longing for the stars, longing for the moon" is the proverb that inspired the flag of China (p. 210). The "Great Savior" of the Chinese people, embodied by a larger star, Mao Tse Tung laid out the idea of 4 smaller stars in one of his speeches. He described the 4 social classes that make up the Chinese people: workers, farmers, the petit-bourgeois and patriotic capitalists.

The 5-pointed star of the Vietnamese flag (p. 211) represents the 5 groups of workers who together built socialism.

Similarly, the 4 stars arrayed at the cardinal points on the Micronesian flag (p. 212) embody its 4 Federated States, although geographically the States are located from west to east.

The star on the flag of Somalia (p. 213) is called the *Étoile de l'unité* (Unity Star) — a symbol of the Somalian people, who also inhabit Djibouti, Ethiopia, Kenya and other former British and Italian colonies.

On the Samoan flag (p. 215), the 5 stars evoke the constellation known as the Southern Cross: Alpha, Beta, Gamma, Delta and Epsilon (the smallest, as it shines less brightly than the other four).

The star on the flag of North Korea (p. 216) relates to communist symbology. It is seen within a circle that stands for the universe.

The 10 stars on the flag of Cape Verde (p. 217) stand for the nation's main islands. The layout of its stars is similar to the design on the European Union flag.

The Republic of Nauru (p. 218) is represented by a 12-pointed white star positioned beneath the line of the Equator. Each point stands for one of the island's 12 indigenous tribes.

The 24 points on the Marshall Islands' flag (p. 219) are the electoral districts, with the 4 longest branches representing the main population centers: Majuro, Jaluit, Wotje and Ebeye.

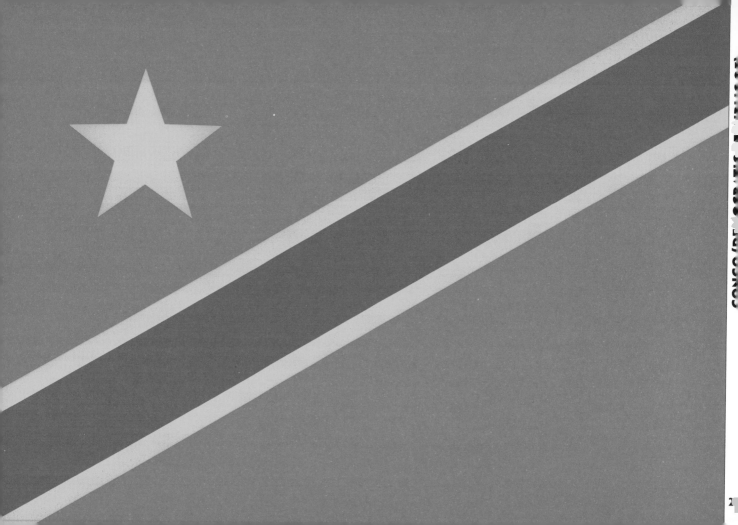

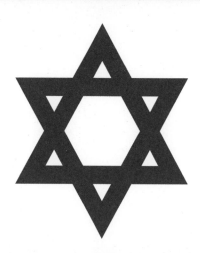

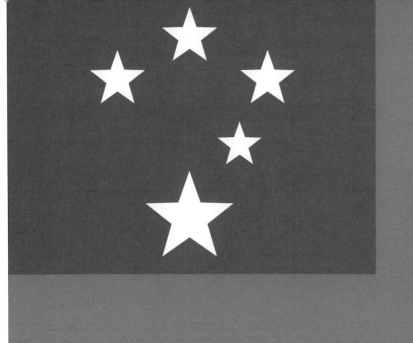

DECORATIONS

Most flags are extremely easy to reproduce. Young children can often draw the flag of their country even before they can read. In some cases, however, the task would be more difficult — for example, when the decorative element is based on local vegetation. This is so for the *rushnyk*, a ceremonial cloth used in Slavic ceremonial rituals.

This complex decoration, highly unusual in flags, is linked to the cultural patrimony of Belarus (p. 222).

Turkmenistan is famous for its carpets, and each tribe has its own *gul* (medallion). The decorative layout of its flag (p. 223) shows 5 traditional carpets that are associated with its 5 main tribes: Tekke, Yomud, Saryq, Choudur and Ärsary.

Tekke

Yomud

Saryq

Choudur

Ärsary

Kazakhstan p. 176

ARMS

World history is a series of conflicts using weapons. Empires, states and nations were made and unmade at the point of a sword. The national emblem of Haiti (p. 274) shows cannons on a verdant hill, ready to defend freedom.

Oman's national emblem is made up of a *khanjar* (a traditional knife carried by men during ceremonies) in its sheath (p. 228), placed on two crossed blades. The emblem was adopted in the 18th century by the royal family of Oman, then became that of the sultanate.

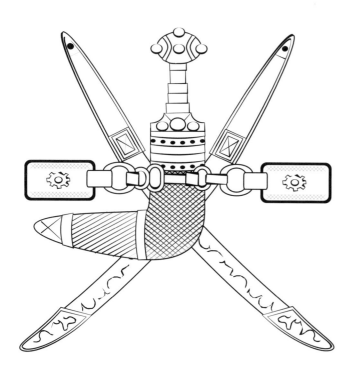

Mozambique's flag (p. 229) shows a Kalashnikov with a bayonet mounted on its barrel. It is one of 2 flags of United Nations member states that display a firearm. The other is Guatemala's (p. 252).

The Kenyan flag (p. 230) displays the traditional black, red and white shield of the Maasai, with the 2 lances that symbolize defense of the country.

The flag of Swaziland (p. 231) shows a Nguni shield and 2 lances, symbolizing protection against the enemy. The design is based on a flag commissioned by King Sobhuza II, who had the longest reign in history (82 years).

The machete on the Angolan flag (p. 232) refers to the country's peasants, agricultural products and armed struggle.

The Barbados flag (p. 233) features a trident, which is the emblem of Neptune, god of the sea, and reflects the enormous importance of the ocean to this island nation. The trident is broken, to indicate independence from the United Kingdom. The 3 points of the trident stand for the 3 principles of democracy.

The sword featured on the flag of Saudi Arabia (p. 293) is the symbol of the Saud dynasty. Abdulaziz Al-Saud was its first monarch. It evokes power and strength, and points in the direction the scriptures are to be read, from right to left.

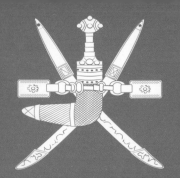

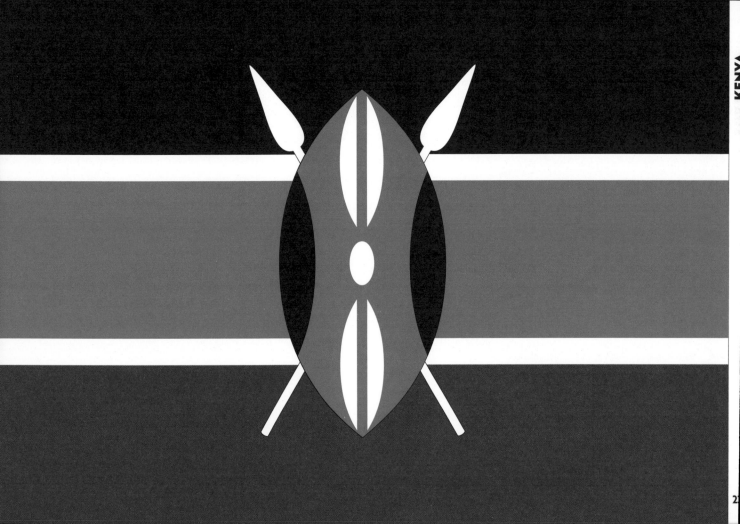

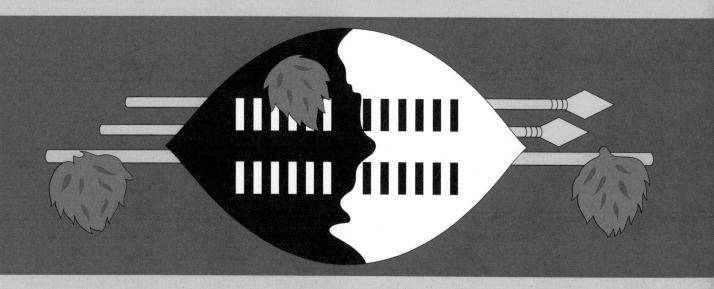

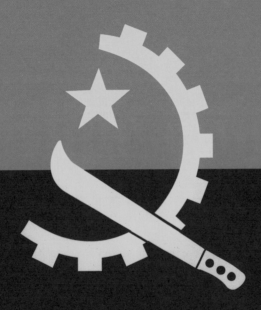

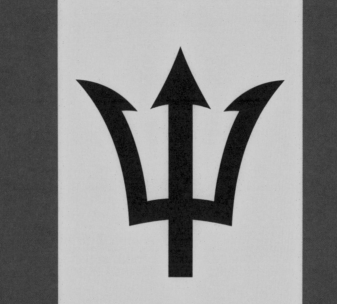

CROWNS

A drawing of the Serbian flag (p. 240) appears on a 1339 map drawn by a cartographer of the era, Angelino Dulcert. At the time, Serbia was administered by King Stefan Dušan.

Liechtenstein added a crown to its flag (p. 237) after the Olympic Games in 1936. It was then that its government realized that its flag was identical to Haiti's (p. 274).

The crown on the flag of Tajikistan (p. 238) stands for the Tajik people. In folk etymology, the name "Tajik" is related to the Persian *tâj* (crown).

The smallest country in the world, the Vatican, shows the papal tiara on its flag (p. 239).

This crown has been worn by the Catholic Church's popes since the 8th century.

From left to right, the Croatian flag (p. 241) shows the coats of arms of Croatia, Dubrovnik, Dalmatia, Istria and Slavonia.

The origin of the Spanish flag (p. 236) is the naval insignia of 1785, the flag of Charles III's marine forces. The king himself made the choice from 12 flag designs.

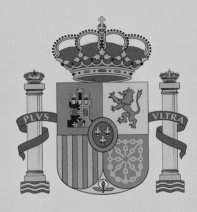

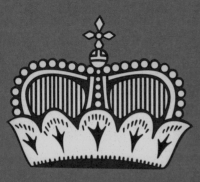

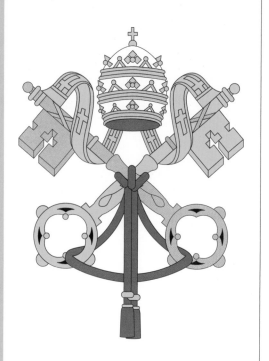

This flag is one of only two national flags in the world that are square, along with that of Switzerland (p. 141).

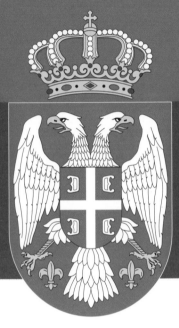

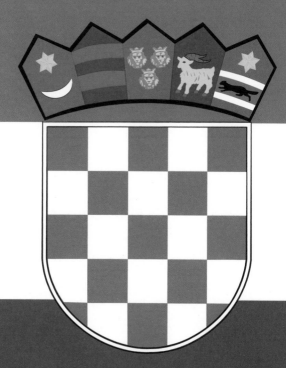

ANIMALS

Some flags feature animals with significant symbolic meaning; the lion and the eagle seem to be the most popular, as they evoke strength and freedom. But some flags show other animals, real or mythological.

The flag of Bhutan (p. 246) features a dragon adorned with sacred jewels.

Andorra, a minuscule country located between France and Spain, features the colors of both these countries on its flag (p. 244). The two cows with their cowbells commemorate the former French province of Béarn.

The boar tusk on the Vanuatu flag (p. 134) is a symbol of prosperity.

 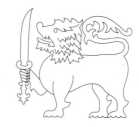

The national animal of Peru is the vicuña, which symbolizes Peru's rich fauna and embodies freedom and heroism. For Peruvians, the flag's colors, chosen by General San Martín, are linked to the values of freedom (p. 245). Arriving at the coast in the midst of the battle for independence, the general was inspired by the local *parihuanas*, red and white Andean flamingos, soaring across the sky.

The llama is the emblematic animal of Bolivia (p. 266), an animal that has been part of the Andean peoples' life for thousands of years.

Sri Lanka's flag (p. 247) features a golden lion holding a short sabre called a *kastane*, and the flag of Spain (p. 236) shows a lion wearing a crown. The Lion of Judah in the middle of Montenegro's flag (p. 261) evokes the biblical theme of resurrection.

On the flag of Fiji (p. 156) we see a British lion holding a coconut.

VIRTVS VNITA FORTIOR

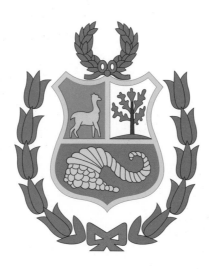

PER

5

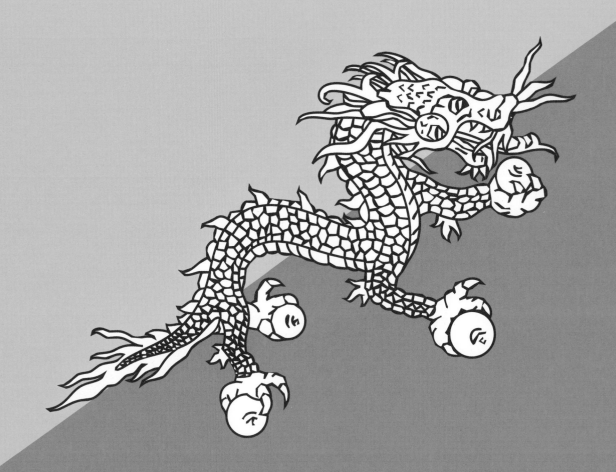

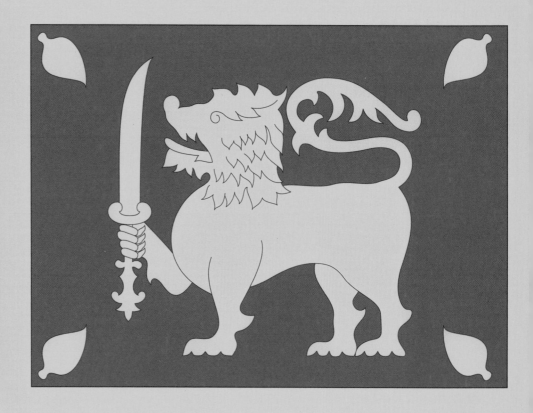

BIRDS

Relationship with the sky has inspired numerous countries to feature birds on their flags. Birds are considered a supernatural link between earth and sky. They represent passage between the physical and spiritual worlds. Birds in flight evoke freedom, and make a perfect symbol of the successful fight for independence or the aspiration to a higher destiny.

The eagle is one of the heraldic attributes often used on various countries' or peoples' flags and shields, thanks to the virtues of strength, dignity and courage attributed to the regal bird.

The two-headed eagle is another common heraldic figure. This is an inheritance from the Byzantine Empire: the head on the left (west) stands for Rome, the one on the right (east) Constantinople.

Resplendent Quetzal – *Pharomachrus mocinno*

Guatemalans believe that the quetzal cannot be raised in captivity, and indeed, it has been verified that when captured, the birds killed themselves. It has thus become a symbol of liberty (p. 252). This tropical bird was considered divine by the Aztecs and the Mayas.

Imperial Amazon – *Amazona imperialis*

The Imperial Amazon parrot is considered the "Pride of Dominica" (p. 253). It is a protected species, probably among the oldest species of Amazon parrots. It is found solely on the island, which the birds have inhabited for hundreds of thousands of years. It can live to the age of 70.

Grey-crowned crane – *Balearica regulorum*

This elegant bird found in Uganda appears in the middle of a white circle on the country's flag (p. 254), symbolizing a bright future. The bird's raised leg indicates that the country is in movement. In perfect harmony with the flag's colors, it evokes the diversity of the African nation's wildlife as well as the gentle nature reflected in the character of the Ugandan people.

Raggiana bird of paradise – *Paradisaea raggiana*

The golden bird of paradise is a local tribal symbol, representing the emergence of Papua New Guinea as a nation. The flag's background colors, red and black, are seen in its crafts and traditional clothing. A 15-year-old schoolgirl created the design (p. 255), winning a national competition in 1971.

Dove – *Columbidae*

The dove of peace first appeared on Fiji's flag
(p. 156) during the reign of King Cakobau,
whose government was the last one before
British administration took over.

Frigatebird – *Fregatidae*

The frigatebird shown on the flag of Kiribati
(p. 180) is able to fly for weeks without landing.
It evokes freedom, authority, power and mastery
of the sea. The flag depicts the archipelagos'
geographic specifics, sprinkled on both sides
of the Equator along a distance of some 2,500
miles, over an area of the Pacific covering
1,158,000 square miles.

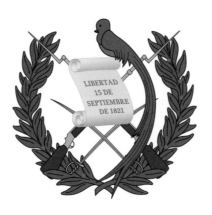

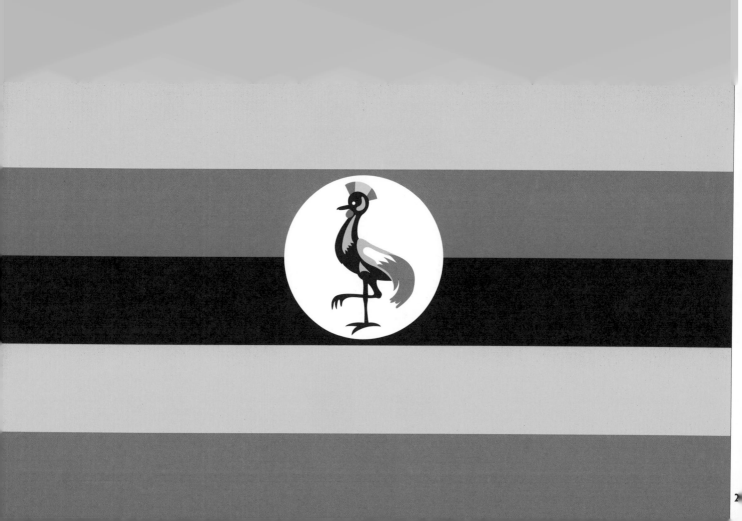

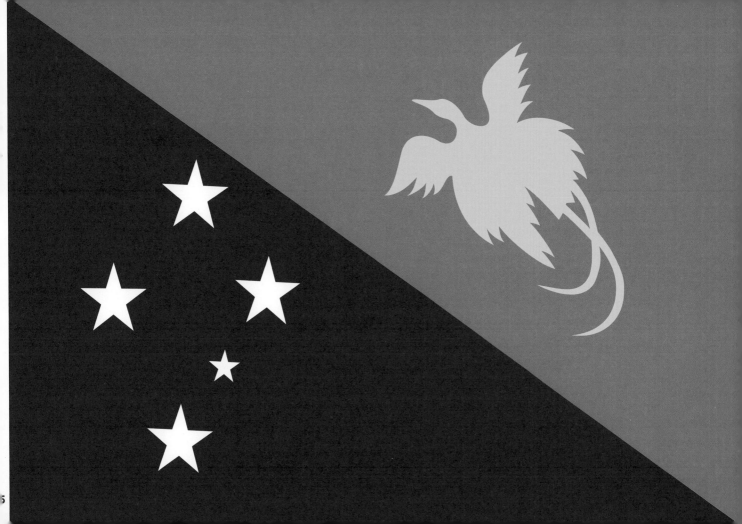

EAGLES

The bird on the Albanian flag (p. 260) is an impressive two-headed eagle, the symbol of the Byzantine Empire of which the country was once a part. It is believed that Albanian nationalists used this bird as an emblem of independence in homage to the combat waged against the Ottoman Empire by Albania's national hero, Prince Skanderbeg, around 1443.

The coat of arms of Montenegro is a two-headed golden eagle that stands for the unity of Church and State. A shield bearing the image of the Lion of Judah (a symbol of resurrection) protects the eagle. Above the eagle is a crown of gold, and in its talons are a scepter and a golden sphere (p. 261).

The **African fish eagle (*Haliaeetus vocifer*)** that appears on Zambia's flag (p. 262) stands for its people's capacity to surmount difficulties, and the orange color evokes its natural and mineral resources. The Zambian flag may be flown legally only between sunrise and sunset.

The **Steppe eagle (*Aquila nipalensis*)** on the flag of Kazakhstan (p. 176) is a bird of prey. Various Kazakh tribes throughout the centuries have featured a golden eagle on their flags. The eagle embodies state power, and for modern-day Kazakhstan evokes independence, freedom and an airborne trajectory toward the future.

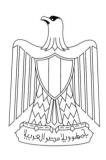

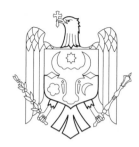

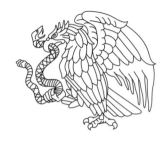

The Egyptian flag bears the national emblem, the eagle of Saladin (p. 263). Saladin was a 17th-century sultan who wrested Jerusalem and Syria (p. 82) from the crusaders who had conquered them.

The eagle on Moldova's flag (p. 264) holds an Orthodox cross in its beak. Instead of a sword, the eagle clutches in its talons an olive branch, the symbol of peace.

The Mexican flag recalls an Aztec legend: the priest Tenoch had predicted that the Mexican people would settle upon the spot where they would see an eagle perched on a cactus devouring a snake (p. 265). Thus it was on this site, by the shores of Lake Texcoco, that they built the Aztec city of Tenochtitlán (today Mexico City). Before the 1968 Olympic Games, the Mexican flag was often used without the central image, but with this omission the flag is quite similar to the Italian flag.

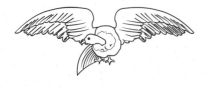

Andean condor –
Vultur gryphus

The Andean condor is the national bird of Argentina, Chile, Colombia and Peru, and plays an important part in Andean folklore and mythology. On the flags of Ecuador (p. 22) and Bolivia (p. 266) the bird looks down on the nation and protects it with its spread wings. The symbol of power and courage, it is also ever watchful, ready to vanquish its enemies.

Bateleur eagle –
Terathopius ecaudatus

In the Shona culture, the eagle is considered a "bird from paradise." It brings light, and is called metaphorically "the needle that sews together heaven and earth." Statuettes of the bird have been found in the ruins of Great Zimbabwe, and it has become a symbol of Zimbabwe's history (p. 267).

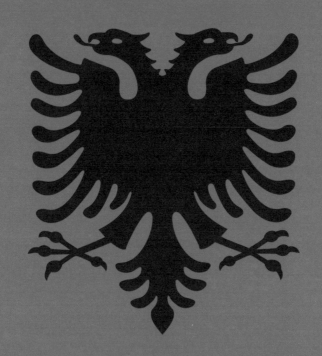

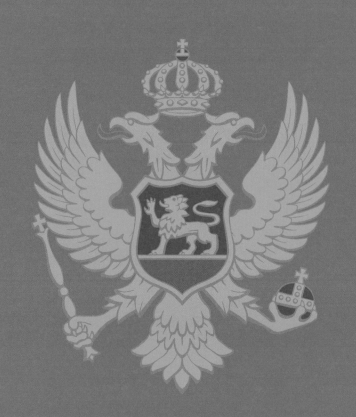

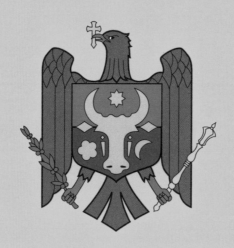

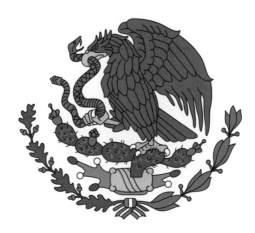

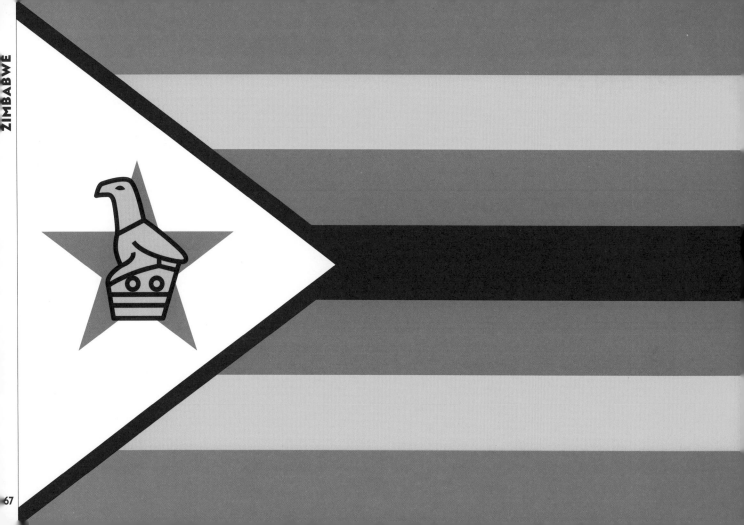

PLANTS

Sycamore maple –
Acer pseudoplatanus

Canada displays a maple leaf on its flag (p. 272), signifying the country's concern for nature and the environment. The maple is to Canada what the cedar is to Lebanon.

Cedar of Lebanon –
Cedrus libani

An evergreen cedar that can grow up to 130 feet tall, originating in the Mediterranean basin, the cedar is the symbol of Lebanon. The tree stands for the sacred, eternity, peace and longevity (p. 273).

Mahogany – *Swietenia*

A mahogany tree is seen in the center of the flag of Belize (p. 275). It represents the country's economic foundations.

Palm tree – *Areca*

The coconut palm on Haiti's flag is known as the "tree of life" (p. 274). Earlier, the flag had been made up of a blue band and a red band, but at the Berlin Olympic Games in 1936, it was discovered that the flag of Liechtenstein (p. 237) was identical to it.

Kapok tree – *Ceiba pentandra*

The flag of Equatorial Guinea (p. 276) displays this tropical tree, also know as the "God tree," beneath which, according to legend, the first treaty was signed between Spain and a local leader.

Traveler's palm – *Ravenala madagascariensis*

Where is the tree on Madagascar's flag (p. 277)? The traveler's palm is represented by the green band. The tree has long leaves that spread out like a giant fan, converging at its base in a huge "cup." The leaves serve as reservoirs of rainfall.

Breadfruit tree –
Artocarpus altilis

The tree seen on the flag
of Bolivia (p. 266) is the
breadfruit tree.

Nutmeg – *Myristica fragrans*

The nutmeg shown on the flag
of Grenada (p. 204), nicknamed
the "Spice Island," is its most
famous product.

The Peruvian flag (p. 245)
features a Cinchona, a shrub
that is used to make quinine,
a powerful medicine for
treating malaria.

Cycad – *Cycadophyta*

On Vanuatu's flag (p. 134),
the 2 leaves of the indigenous
cycad symbolize peace.

Olive tree – *Olea europaea*

The symbolic yellow crown that appears on the Eritrean flag (p. 122) has 30 leaves (12 on each side and 6 in the center). This stands for the number of years of the civil war that preceded the country's independence.

The olive branch of the flag of Cyprus (p. 280) evokes peace. The flag has peaceful, neutral symbols as a gesture of harmony in the relations between the Greeks and the Turks.

Cactus – *Opuntia*

According to Mexican mythology, the fruit of the nopal cactus on the Mexican flag (p. 265) sprang from the heart of Cópil, nephew of the Aztec god Huitzilopochtli. In legend (see p. 258), the city of Tenochtitlán was built at the precise spot where the heart had been left.

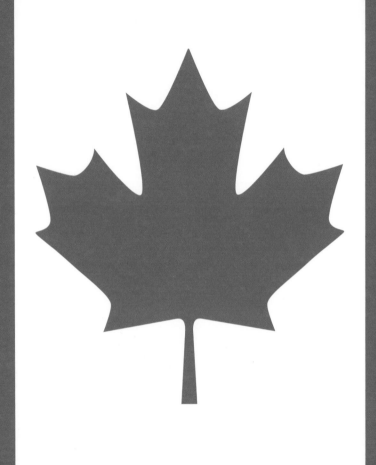

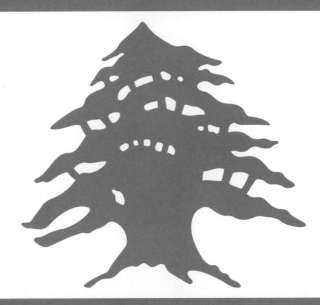

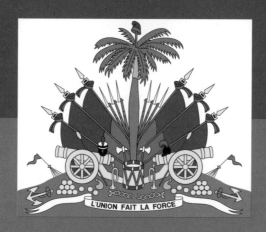

L'UNION FAIT LA FORCE

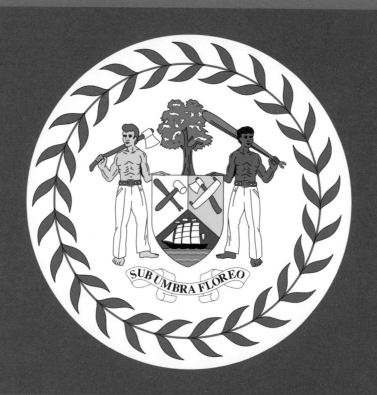

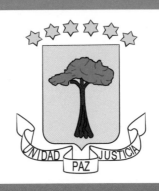

MAPS

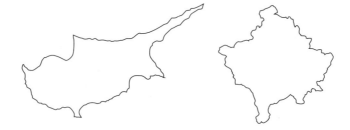

The use of maps as an element in flag design is rare. One proposal for the continent of Antarctica would have a white map on a blue background. However, this is not an official flag, as Antarctica is not a country.

On the flag of Cyprus (p. 280), the silhouette of the island is colored a coppery orange, symbolizing the country's substantial mining reserves of the metal. In fact, Cyprus means copper, as both words derive from the Greek *kyprios*.

The flag of Kosovo (p. 281) has the same colors as that of Bosnia and Herzegovina (p. 120): white stars and a yellow outline against a blue background.

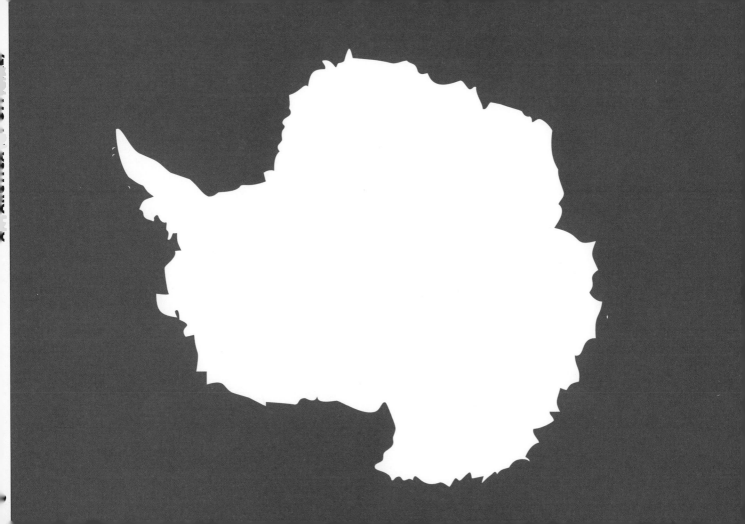

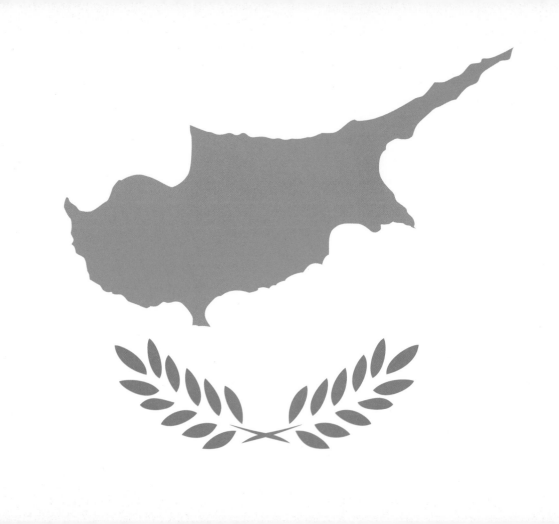

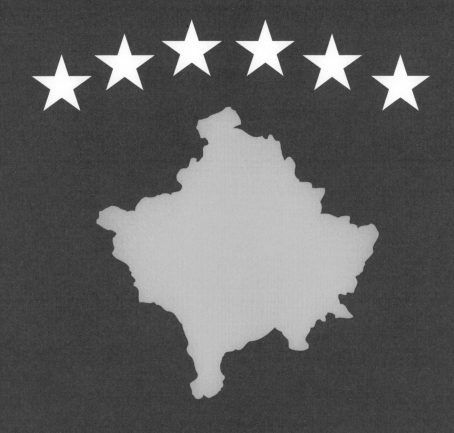

BUILDINGS

Afghanistan's flag (p. 286) shows a mosque with its minaret facing Mecca.

On the flag of Cambodia (p. 284) we see a stylized drawing of the temple of Angkor Wat, the largest religious monument in the world.

The flag of San Marino (p. 285) features 3 watchtowers on the peaks of Monte Titano ("Mount Titan").

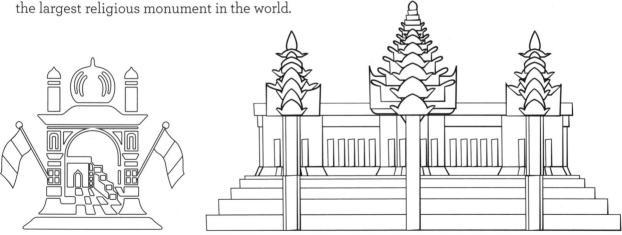

The Portuguese flag (p. 287) has 7 castles, symbols of Portugal's victories in 1249 under the reign of Afonso III. Their origin can be traced to Castilia, whose coat of arms consists of a golden castle on a red background.

A similar castle appears on the flag of Spain (p. 236), next door, in a different style. It is seen between the two pillars of Hercules that symbolize the Strait of Gibraltar.

On the Bolivian flag (p. 266), the "Casa de la Moneda" (mint) symbolizes the country's industry and wealth.

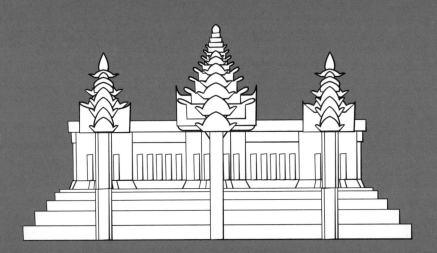

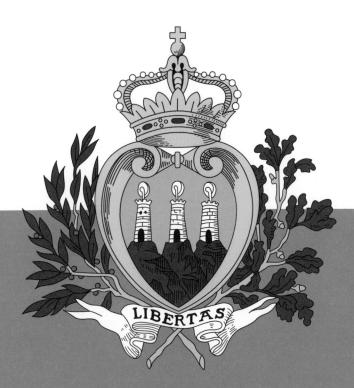

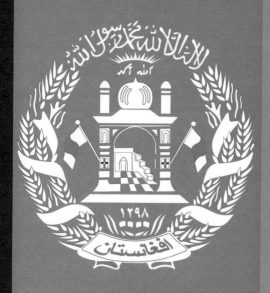

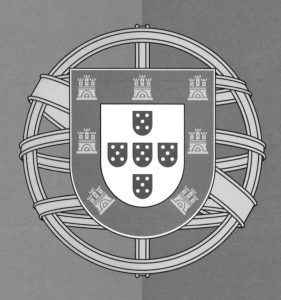

WORDS AND MOTTOES

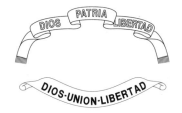

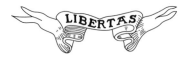

LIBERTAD
15 DE
SEPTIEMBRE
DE 1821

Some countries (Bolivia, Paraguay, Nicaragua and El Salvador) include their name on their flags. Others present messages.

To celebrate their independence, many nations choose to emphasize the word "Liberty": *Dios, Patria, Libertad* is the motto seen on the flag of the Dominican Republic (p. 144); *Dios, Unión, Libertad* on that of El Salvador (p. 43); and

Libertas on that of San Marino (p. 285). The Guatemalan flag (p. 252) mentions the date of its independence.

Another word frequently seen is "Unity," which appears on the flags of Equatorial Guinea (*Unidad, Paz, Justicia*, p. 276);

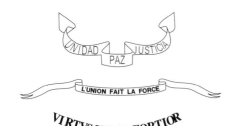

Haiti (*L'union fait la force,* "Unity Is Strength," p. 274), and Andorra (*Virtus unita fortior,* "Virtue United Is Stronger," p. 244).

Two words are seen on Spain's flag (p. 236): *Plus ultra* ("Farther").

The motto *Ordem e Progresso* ("Order and Progress") was inspired by the principles of positivism*: "Love as principle, order as basis, progress as end." This is the message of the Brazilian flag (p. 294).

Saint Vincent and the Grenadines have been dubbed "the precious stones of the Antilles." The three precious stones are arranged in the shape of a V, the first letter of Vincent (p. 295).

Since Islamic religion does not permit representation of living beings, calligraphy is the leading artistic discipline in the Muslim world. *Allahu Akbar* ("God is great") is shown 22 times in white kufic lettering at the edge of the red and green bands on the flag of Iran (p. 292).

The saying, known as the *takbîr*, also appears on the Iraqi flag (p. 83).

The declaration of faith "There is no god but Allah, and Muhammad is his messenger" is written on the flag of Saudi Arabia (p. 293).

"Always in service with God's guidance" is written on the crescent moon on the flag of Brunei (p. 291). The banner beneath it says, "Brunei, the Abode of Peace."

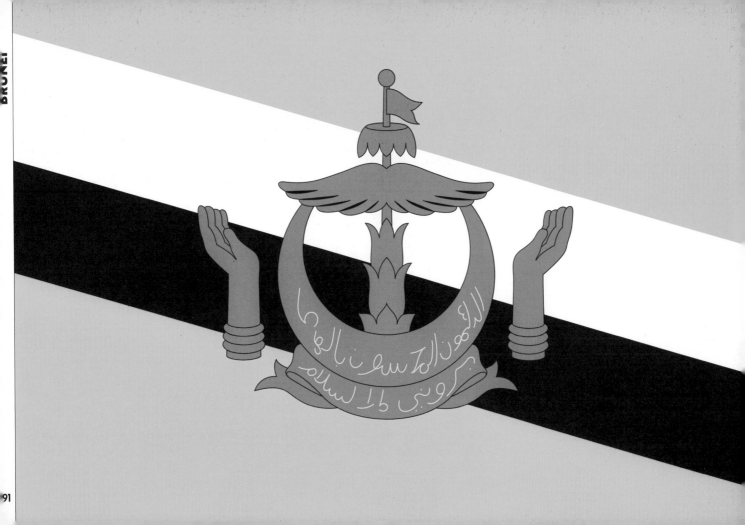

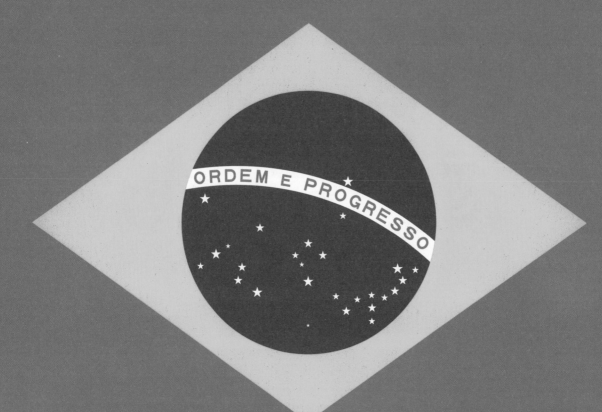

INDEX

This book presents 199 flags: 193 belong to UN Member States — 54 in Africa, 47 in Asia, 35 in the Americas, 43 in Europe and 14 in Oceania. Two countries, the Vatican and Palestine, are Non-member Observer States. Since 1993, Taiwan has been a candidate to become a Member State.

In 2008, Kosovo became independent of Serbia. Puerto Rico is an unincorporated territory of the United States with commonwealth status. Antarctica is a politically neutral territory.

A

Afghanistan p. 286

Albania p. 260

Algeria p. 194

Andorra p. 244

Angola p. 232

Antarctica (unofficial)
 p. 279

Antigua and Barbuda
 p. 181

Argentina p. 182

Armenia p. 61

Australia p. 154

Austria p. 38

Azerbaijan p. 199

B

Bahamas p. 124

Bahrain p. 118

Bangladesh p. 166

Barbados p. 233

Belarus p. 222

Belgium p. 101

Belize p. 275

Benin p. 108

Bhutan p. 246

Bolivia p. 266

Bosnia and Herzegovina
 p. 120

Botswana p. 92

Brazil p. 294

Brunei p. 291

Bulgaria p. 54

Burkina Faso p. 114

Myanmar (Burma) p. 73

Burundi p. 137

C

Cambodia p. 284

Cameroon p. 110

Canada p. 272

Cape Verde p. 217

Central African Republic
 p. 89

Chad p. 102

Chile p. 161

China p. 210

Colombia p. 23

Comoros p. 88

Congo p. 115

· Congo (Democratic
 Republic of) p. 206

Costa Rica p. 46

Croatia p. 241

Cuba p. 162

Cyprus p. 280

Czech Republic p. 35

D

Denmark p. 147

Djibouti p. 207

Dominica p. 253

Dominican Republic
 p. 144

E

East Timor p. 125

Ecuador p. 22

Egypt p. 263

El Salvador p. 43

Equatorial Guinea p. 276

Eritrea p. 122

Estonia p. 57

Ethiopia p. 107

F

Fiji p. 156

Finland p. 151

France p. 95

G

Gabon p. 58

Gambia p. 93

Georgia p. 142

Germany p. 60

Ghana p. 72

Greece p. 145

Grenada p. 204

Guatemala p. 252

Guinea p. 105

Guinea-Bissau p. 109

Guyana p. 123

H

Haiti p. 274

Honduras p. 41

Hungary p. 53

I

Iceland p. 149

India p. 70

Indonesia p. 31

Iran p. 292

Iraq p. 83

Ireland p. 99

Israel p. 209

Italy p. 96

Ivory Coast p. 98

J

Jamaica p. 136

Japan p. 165

Jordan p. 79

K

Kazakhstan p. 176

Kenya p. 230

Kiribati p. 180

Kosovo p. 281

Kuwait p. 75

Kyrgyzstan p. 174

L

Laos p. 168

Latvia p. 39

Lebanon p. 273

Lesotho p. 67

Liberia p. 160

Libya p. 189

Liechtenstein p. 237

Lithuania p. 55

Luxembourg p. 52

M

Madagascar p. 277

Malawi p. 185

Malaysia p. 196

Maldives p. 193

Mali p. 104

Malta p. 143

Marshall Islands p. 219

Mauritania p. 192

Mauritius (Republic of) p. 87

Mexico p. 265

Micronesia p. 212

Moldova p. 264

Monaco p. 30

Mongolia p. 197

Montenegro p. 261

Morocco p. 208

Mozambique p. 229

N

Namibia p. 184

Nauru p. 218

Nepal p. 117

Netherlands p. 51

New Zealand p. 155

Nicaragua p. 42

Niger p. 71

Nigeria p. 97

North Korea p. 216

North Macedonia p. 175

Norway p. 148

O

Oman p. 228

P

Pakistan p. 195

Palau p. 167

Palestine p. 78

Panama p. 214

Papua New Guinea p. 255

Paraguay (recto) p. 66

Paraguay (verso) p. 65

Peru p. 245

Philippines p. 178

Poland p. 34

Portugal p. 287

Puerto Rico p. 163

Q

Qatar p. 119

R

Romania p. 103

Russia p. 56

Rwanda p. 177

S

Saint Lucia p. 121

Saint Kitts and Nevis
p. 132

Saint Vincent and the
Grenadines p. 295

Samoa p. 215

San Marino p. 285

São Tomé and Principe
p. 112

Saudi Arabia p. 293

Senegal p. 111

Serbia p. 240

Seychelles p. 129

Sierra Leone p. 59

Singapore p. 33

Slovakia p. 68

Slovenia p. 69

Solomon Islands p. 130

Somalia p. 213

South Africa p. 135

South Korea p. 169

South Sudan p. 85

Spain p. 236

Sri Lanka p. 247

Sudan p. 84

Suriname p. 205

Swaziland p. 231

Sweden p. 150

Switzerland p. 141

Syria p. 82

T

Taiwan p. 179

Tajikistan p. 238

Tanzania p. 131

Thailand p. 47

Togo p. 113

Tonga p. 140

Trinidad and Tobago p. 133

Tunisia p. 191

Turkey p. 190

Turkmenistan p. 223

Tuvalu p. 157

U

Uganda p. 254

Ukraine p. 29

United Arab Emirates p. 76

United Kingdom p. 153

United States of America
 p. 159

Uruguay p. 183

Uzbekistan p. 198

V

Vanuatu p. 134

Vatican p. 239

Venezuela p. 21

Vietnam p. 211

Y

Yemen p. 80

Z

Zambia p. 262

Zimbabwe p. 267

GLOSSARY

Coat of arms: an emblem of a family, group or country, initially represented on shields used in combat.

Heraldry: the study of coats of arms, which, in many cases, became the basis for current flags.

Cabalists: specialists in cabala, a mystical and esoteric discipline derived from Judaism.

Pan: prefix from the Greek that means "everything," that is, the union of all the branches of a group.

Pan-African: political union movement of African countries.

Pan-Arab: ideological unification of the Arab world — the countries of North Africa and the Middle East.

Pan-Slavic: ethnic union of the Slavic peoples of Central and Eastern Europe.

Positivism: a cultural and philosophical movement that influenced the thinking and actions of the founders of the Republic of Brazil.

Ratio: the proportion between the width and height of the flag. This ratio varies by country: most flags (about half) have a ratio of 2:3, which is close to what is called the golden ratio in mathematics. Almost a quarter of all flags have a ratio of 1:2.

Zionism: movement that supports the idea of the resettlement of the Jewish people on the biblical lands of Israel (also called Zion).

Library of Congress Cataloging-in-Publication Data data available.

ISBN 978-1-4521-8265-0

Manufactured in Hong Kong.

MIX
Paper from responsible sources
FSC www.fsc.org FSC™ C136333

10 9 8 7 6 5 4 3 2 1

Chronicle books and gifts are available at special quantity discounts to corporations, professional associations, literacy programs, and other organizations. For details and discount information, please contact our premiums department at corporatesales@chroniclebooks.com or at 1-800-759-0190.

Chronicle Books LLC
680 Second Street
San Francisco, California 94107
www.chroniclebooks.com